IMAGES
of America

FIREFIGHTING IN ROANOKE

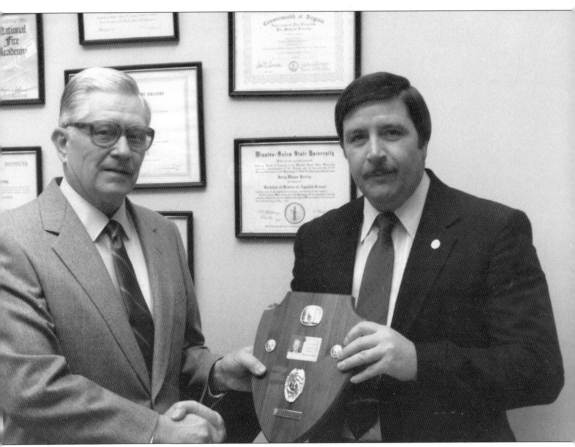

Capt. Maurice Wiseman (left) was the historian of the Roanoke Fire Department. Captain Wiseman kept every fire-related newspaper clipping from the early 1960s up until the mid-1990s. Captain Wiseman was hired June 1, 1950, and retired on March 2, 1985, after 35 years of service to the City of Roanoke. Captain Wiseman is pictured receiving his retirement plaque from Chief Jerry Kerley. (Courtesy of Roanoke Fire Fighters Association Historical Archive.)

ON THE COVER: Ladder No. 1, a 1918 Seagrave, sits next to the chief's car, a Hudson, at Fire Station No. 1. The men on the ladder are, from left to right, Eslie J. Knowles, ? Shillins, James E. Updike, Harry Grubb, Raymond N. Wills, Harry J. Daniels, and Ernest Boitnott. The men at the chief's car are Marvin Stevens (left) and Victor R. Metz. (RFFA.)

IMAGES
of America

FIREFIGHTING IN ROANOKE

Rhett Fleitz on behalf of the
Roanoke Fire Fighters Association

ARCADIA
PUBLISHING

Published by Arcadia Publishing
Charleston SC, Chicago IL, Portsmouth NH, San Francisco CA

Printed in the United States of America

Library of Congress Catalog Card Number: 2006930586

For all general information contact Arcadia Publishing at:
Telephone 843-853-2070
Fax 843-853-0044
E-mail sales@arcadiapublishing.com
For customer service and orders:
Toll-Free 1-888-313-2665

Visit us on the Internet at www.arcadiapublishing.com

To Roanoke's bravest

To Becky, Preston, and Jade

CONTENTS

ACKNOWLEDGMENTS

I am deeply indebted to the late Capt. Maurice Wiseman, without whom this work would have been nearly impossible. For nearly a half century, Captain Wiseman collected articles and artifacts related to the history of our fire department. His dedication to our heritage echoes through these pages. I would also like to thank his family for graciously bestowing this collection to the Roanoke Fire Fighters Association (RFFA) after his passing.

The assistance of Travis Collins, who converted most of the images that follow into a digital format, was of enormous value. His work in completing the digital archives of the Maurice Wiseman Project has given me the opportunity to concentrate on this book. Thanks to all of the Roanoke firefighters, both past and present, who have assisted me in documenting our history as accurately as possible. These include Warren Hawley, Alvis Kelley, Corbin Wilson, Jimmy Jennings, Pete Smith, Pete Price, Bev Mitchell, and the Bohon family. Several current firefighters who share enthusiasm of our history were able to contribute to the book. These firefighters include Michael Banks, Willie Wines Jr., Craig Sellers, Baron Gibson, Travis Collins, David Wray, and Scott Boone.

The History Museum of Western Virginia, especially Kent Chrisman, was an integral source for this book. I appreciate the assistance from the librarians of the Virginia Room at the Downtown Roanoke Library. Special thanks go to Jane Wills of the Virginia Tech Imagebase for their assistance in getting me the historic images we were lacking. Most of all, I am thankful to my loving wife, Becky, and our two children.

INTRODUCTION

Firefighting in Roanoke celebrates the history of fire service in the city of Roanoke, Virginia. Our history begins with the volunteers of the late 19th century and continues to the current Roanoke Fire-EMS Department 125 years later. The city of Roanoke will celebrate its 125th anniversary in 2007, and the firefighters have a lot to celebrate. The year also marks 125 years of organized firefighting in Roanoke: February is the 100th anniversary of the opening of Fire Station No. 1, while March marks the 100th anniversary of a fully paid fire department.

Roanoke's fire service has changed quite a bit since the days of hand-pulled hose wagons and makeshift alarm bells. Being a Roanoke firefighter has always been an honorable profession. In the beginning, only the well-known businessmen and upstanding citizens were allowed to be firefighters. Most of the firefighters were also members of local societies. While the quality of our firefighters has never changed, the make-up of our department has certainly seen milestones. In the 1960s, Roanoke welcomed its first black firefighters, followed by its first females in the 1990s. The Roanoke Fire Department, now the Roanoke Fire-EMS Department, continues to be the most progressive department in southwest Virginia.

The hard work and dedication Maurice Wiseman put toward our history is a tribute to the approximate 1,200 firefighters who have protected the City of Roanoke. The stories of the last 125 years have been passed on generation to generation, some good and others bad. The stories are told to relate our past, to teach the history, and to learn for the future. This book celebrates the Roanoke firefighters.

One

THE VOLUNTEERS

The town council minutes of April 13, 1877, gives first mention of establishing a fire department in Big Lick, Virginia. On March 7, 1882, the first fire official was created. A fire marshal was sworn in to inspect flues of houses and report to city council. Later that year, on November 16, 1882, the *Roanoke Leader* published this article: "We have been requested to publish the following notice, which we do with much pleasure: A meeting will be held in the Town Hall on next Monday evening, at half past seven o'clock, for the purpose of organizing a Fire Department. All persons in sympathy with the movement are requested to attend."

Fourteen days later, the *Roanoke Leader* reported: "A meeting of the Fire association was held in River Hall last Monday night and the organization begun on Monday, the 13th inst., was completed. Mr. Craig was elected 3rd and Mr. Reynolds 4th Lieutenant of the Company, and it was Christened 'Roanoke Fire Company No. 1.' "

On August 3, 1891, the constitution and bylaws of the Fire Department Board were created to provide rules and regulations for the various volunteer fire companies. These guidelines went into effect January 1892. The ordinance outlined the regulations of the chief engineer and assistant engineers. The constitution and bylaws were created to provide leadership of the Fire Department Board of the city of Roanoke. They governed the requirements of the officers of the board, as well as the agenda of the mandated monthly meetings.

The first officers of the fire board were Pres. John Engleby, Sec. Llewellyn Lookabill, Chief Engineer James G. Knepp, First Assistant Engineer Joseph T. Engleby, and Second Assistant Engineer James McFall. In effect, James Knepp became the first chief of the fire department of the city of Roanoke in 1892. The Alert Fire Company later joined the fire board to protect the Virginia Brewery and the growing southeast quadrant of the city.

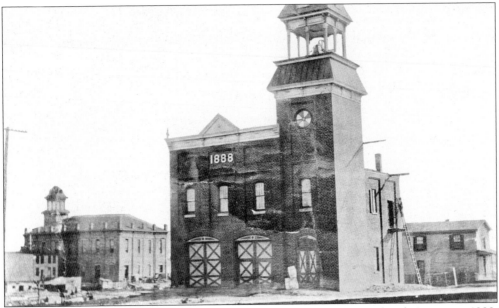

Fire Station No. 1 was built at the northeast corner of Jefferson Street and Kirk Avenue in 1888. The firehouse shown here in 1888 was near completion, just four years after the Vigilant Steam Fire Company was organized. This firehouse remained in use until the new Station No. 1 was opened in 1907 on Church Avenue. After closing its doors permanently in 1907, the building's facade would change many times. Over the next 70 years, the former Station No. 1 was occupied by several businesses before being razed in 1977. The final tenants were Hanover Shoes and Stein's Clothiers. The site is currently a courtyard next to the chamber of commerce. (Courtesy of Norfolk and Western Historical Photograph Collection, (NS 5765), Digital Library and Archives, University Libraries, Virginia Polytechnic Institute and State University.)

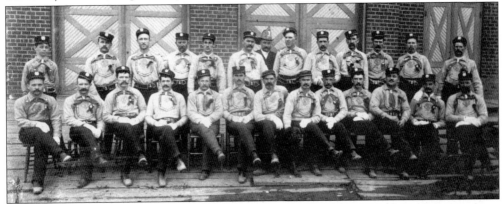

In 1890, the members of the Vigilant Steam Fire Company No. 1 pose in front of the bay doors at Fire Station No. 1. The Vigilantes were the first volunteer fire company in Roanoke. The company was housed in an old carpenter's shop located at Campbell Avenue and First Street prior to having their firehouse built. When there was a fire, a firefighter would strike an old circular saw with an iron rod to summon the rest of the men to respond. The firefighters are, from left to right, (first row) Thomas Engleby, ? Harris, ? Shank, P. C. Shade, ? Peters, ? Cook, ? Poteet, ? Wingfield, John McDermott, ? Story, ? Brook, ? Wingfield, and C. T. Whaling; (second row) James R. Terry, Baughman, ? Wilson, W. R. Hesse, J. P. Swallenberg, R. M. Angell, James G. Knepp, Owen Duggan, George W. Sister, ? Dodson, C. F. Ray, ? Peters, ? Wiley. (RFFA.)

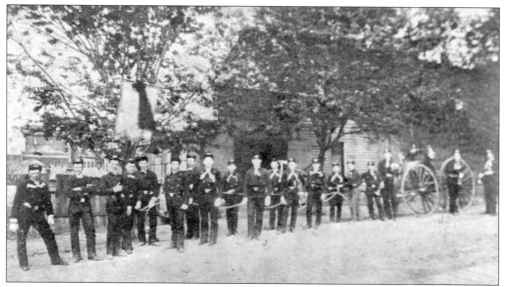

Organized in March 1888, the Junior Hose Company No. 2 was Roanoke's second volunteer fire department. Here Juniors stand in front of Rorer Hall. Rorer Hall was their first fire station. Before the men acquired horses, they had to pull the hose carts. The Juniors moved into Fire Station No. 1 after Rorer Hall burned down, and they remained organized until 1907. (Courtesy of History Museum of Western Virginia [HMWV].)

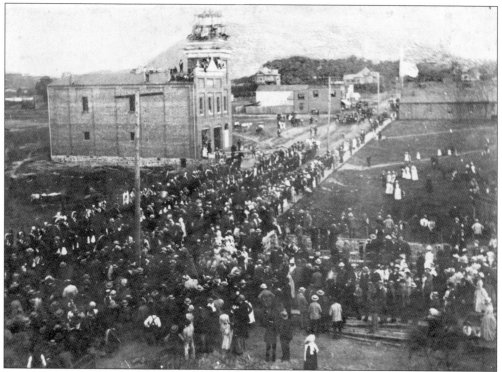

A crowd gathered for the laying of the cornerstone of the Masonic Temple, which was located at the intersection of Jefferson Street and Campbell Avenue. Fire Station No. 1 can be seen in the background of this picture in 1887. (HMWV.)

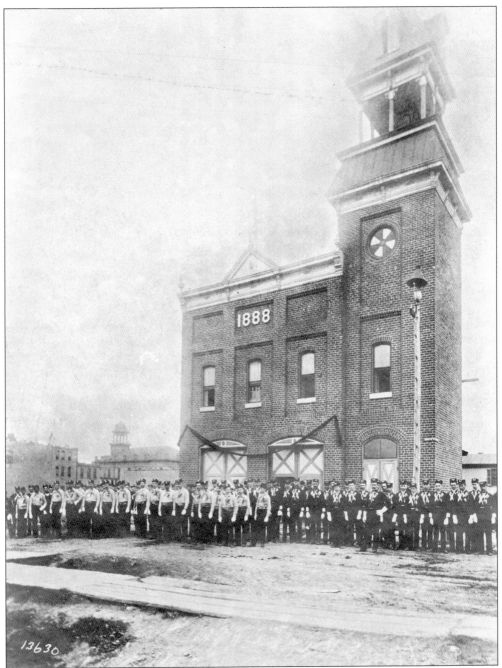

In April 1890, the members of the Vigilant Steam Fire Company No. 1 and the Friendship Fire Company No. 3 stand in front of Fire Station No. 1 shortly before escorting the body of Mayor William Carr to his burial at the city cemetery. The alarm bell, shown on the wooden post, was cast in Baltimore, Maryland, and was later mounted in the tower. (Norfolk and Western Historical Photograph Collection, (NS 5801), Digital Library and Archives, University Libraries, Virginia Polytechnic Institute and State University.)

Fire Station No. 3 was built at the corner of East Street and Fourth Avenue in 1892, approximately where the main post office is located today. The Friendship Fire Company No. 3 was formed to protect the northeast quadrant of the city. This company was originally called the Union Fire Company No. 3 until city council decided that the name "Union" was not befitting the men and had them change it. The Friendship Fire Company was originally housed in the Market area until their firehouse was built. W. H. Stennett was the first chief of the Friendships. Later, when Roanoke switched to a fully paid fire department, this firehouse was renamed Fire Station No. 2 and stayed open until 1951. After being used as a storage building for a couple of years, it was razed in the mid-1950s. (Courtesy of Norfolk and Western Historical Photograph Collection, (NS 5807), Digital Library and Archives, University Libraries, Virginia Polytechnic Institute and State University.)

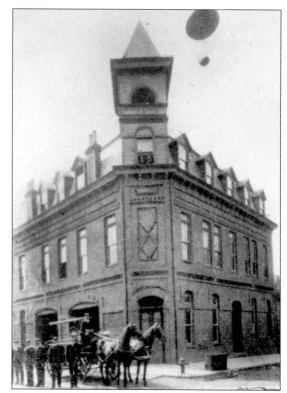

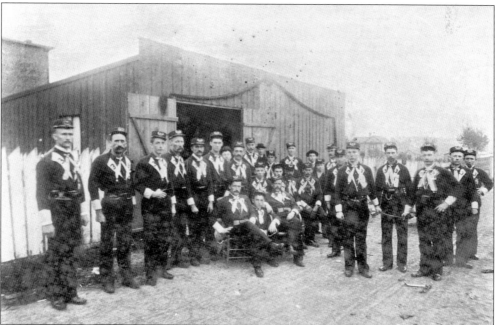

The Friendship Fire Company poses in front of a building that might have been their quarters until Fire Station No. 3 was built in northeast Roanoke. The most pressing need for a firehouse at the time was a place to store their apparatus, horses, feed, and hay. The men did not rely on having living quarters at the station during this era. (HMWV.)

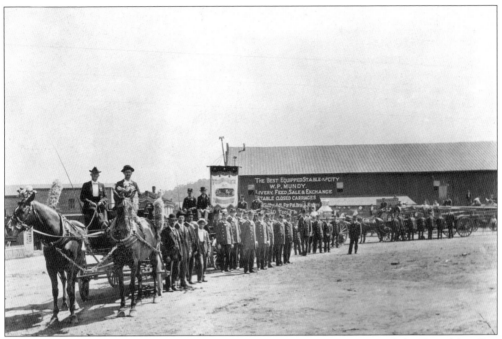

The Vigilant Steam Fire Company No. 1, Junior Hose Company No. 2, and the Friendship Fire Company No. 3 line up for the Labor Day Parade in 1892 near the present corner of Jefferson Street and Church Avenue. (RFFA.)

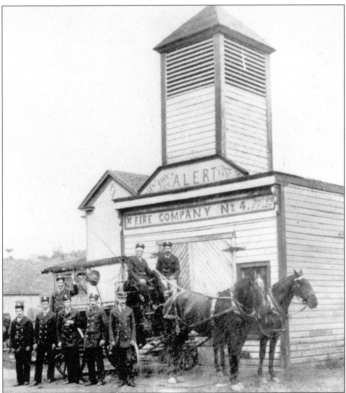

The Alert Fire Company No. 4 was organized to protect the Virginia Brewery and the newly expanding southeast quadrant of the city. This firehouse was located at 1219 Wise Avenue SE, directly across the street from the brewery. The Alerts were organized on November 7, 1892, and disbanded on February 28, 1903. (Courtesy of Norfolk and Western Historical Photograph Collection, (NS 5807), Digital Library and Archives, University Libraries, Virginia Polytechnic Institute and State University.)

Prepared for official publication around 1893, this is believed to be an advertisement for the Roanoke fire companies, otherwise known as the Vigilantes, Juniors, Friendships, and Alerts. The Junior Fire Company is shown in front of Fire Station No. 1. This fire company moved to Fire Station No. 1 after the burning of Rorrer Hall, where they had been housed, around 1888. Both the Vigilantes and Juniors were housed at Fire Station No. 1 until 1893, when the Vigilantes disbanded and the Juniors remained. The men are, from left to right, (top row) Capt. C. W. Hays, Chief James McFall, and Foreman J. E. Rooker; (bottom row) Foreman E. J. McDonald, First Assistant Chief P. J. Minnehan, and Second Assistant Chief J. T. Geisen. (Courtesy of Norfolk and Western Historical Photograph Collection, (NS 5807), Digital Library and Archives, University Libraries, Virginia Polytechnic Institute and State University.)

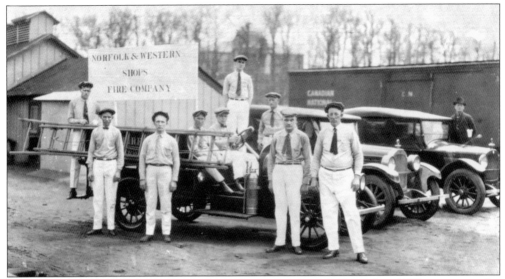

The Norfolk and Western Machine Shops Fire Company was formed in 1882 to protect the machine shops of the Norfolk and Western Railroad. It is unclear when the company disbanded; however, they were still organized for the huge conflagration at the Norfolk and Western's offices in 1896. This company might have been the first fire company in Roanoke, although it was more of a brigade offering fire suppression for the machine shops and only assisting off-premises with large fires. The charter members were David Espenlaub, James A. McConnell, Peter Van Miller, and E. C. Welch. (Courtesy of Norfolk and Western Historical Photograph Collection, (NW 3727), Digital Library and Archives, University Libraries, Virginia Polytechnic Institute and State University.)

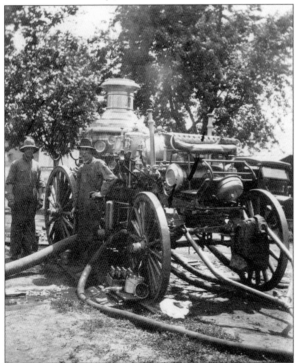

Two firefighters stand by as Steamer No. 1 pumps water. The steamer was bought secondhand from Lancaster, Pennsylvania. Once the horses took the apparatus to the fires, they were unhooked and staged close by. This was for the horses' safety and the safety of the firefighters in case the horses were spooked while still attached to the apparatus. (RFFA.)

Members of the Vigilant Steam Fire Company pose for their portrait. The members of the various fire companies were very proud to be firemen. These members were usually upstanding citizens and businessmen in the community. It was an honor to be a volunteer for one of the fire companies. (RFFA.)

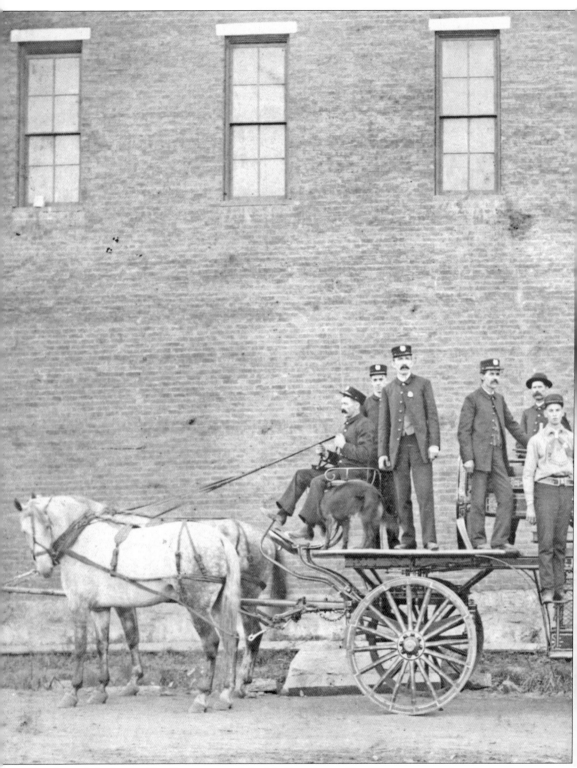

Members of the Junior Fire Company and the Vigilant Steam Fire Company stand on the hook-

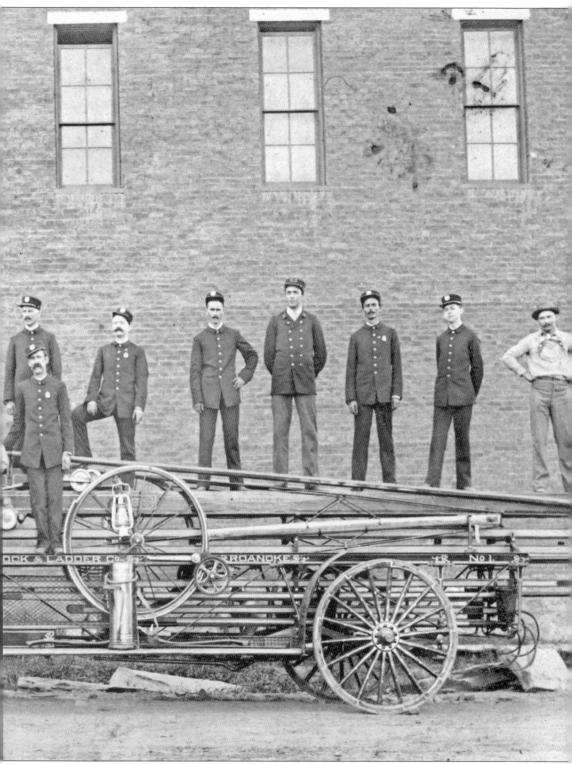

and-ladder truck in the 1890s. (HMWV.)

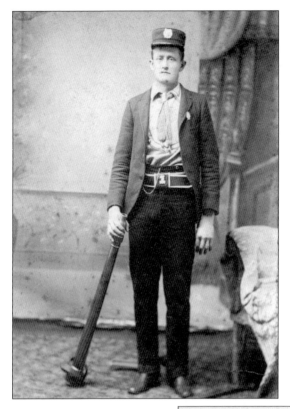

This is a member of the Vigilant Steam Fire Company. The volunteers of the various volunteer fire companies assessed themselves dues, around $2 a month, and paid fines for missing fires, cursing, and spitting on the floor inside the station. The volunteers bought their own uniforms and kept them parade ready. (RFFA.)

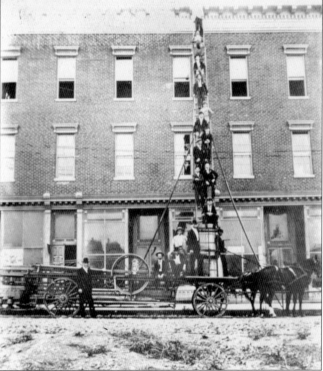

Members of the Junior Fire Company No. 2 demonstrate the city's first hook-and-ladder truck at the Bridgewater Carriage Factory in 1894. The factory was located at Church Avenue and Henry Street (First Street). (HMWV.)

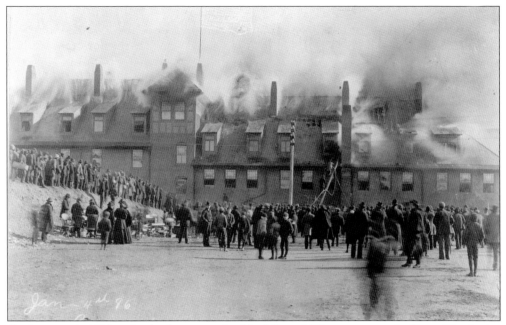

On January 4, 1896, a fire broke out at the Norfolk and Western general offices. The Junior Fire Company was notified around 11:00 a.m., followed by the Alerts, the Friendships, and the Machine Shops Fire Company. The firefighters had to deal with frozen fire plugs, bursting hoses, and extreme cold as well as the fact that the alarm was delayed after the fire was first discovered. The workers in the building salvaged all they could while the fire tore through the building, and they filled the lawn of the Hotel Roanoke with the salvaged items. (Courtesy of the Virginia Room, Roanoke Public Libraries.)

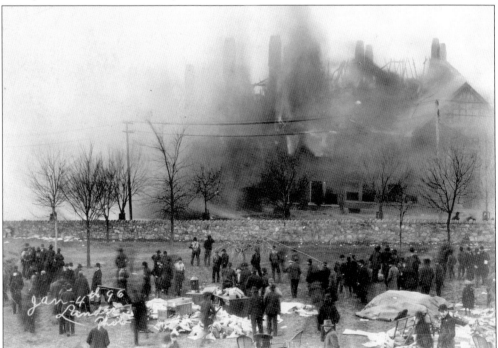

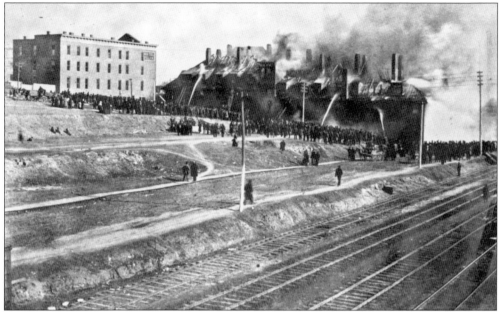

Hundreds of Roanokers watch in horror as the Norfolk and Western general offices continue to burn. After all the smoke cleared, there was not much left to the structure other than the masonry walls and chimneys. (Courtesy of Norfolk and Western Historical Photograph Collection, (NS 3970), Digital Library and Archives, University Libraries, Virginia Polytechnic Institute and State University.)

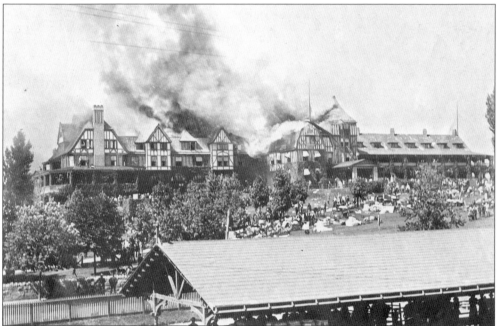

On July 1, 1898, a fire raged at the Hotel Roanoke. Although it destroyed an entire wing of the hotel, the fire looked worse than it was. After being rebuilt, the hotel reopened the following spring. (Courtesy of Norfolk and Western Historical Photograph Collection, (NS 6022), Digital Library and Archives, University Libraries, Virginia Polytechnic Institute and State University.)

Two

THE ROANOKE FIRE DEPARTMENT

The Roanoke Fire Department began with 22 paid men on March 1, 1903. Twelve of the men were constantly on duty, and 10 of them were on call. James McFall was sworn in as the first paid chief of the Roanoke Fire Department. Chief McFall had previously been appointed as the chief of the Volunteers since January 1, 1894. At the request of the city, the remaining volunteers disbanded on March 31, 1907, creating a fully paid department. The men worked six days a week and were allowed to alternate going home for lunch or dinner. The newly created department had two fire stations: a brand new Fire Station No. 1 on Church Avenue in downtown and fire station No. 2. Fire Station No. 2 was originally built for the Friendships as Station No. 3 in the northeast.

The fire department continued to see growth in size and technology. In 1911, the department doubled in size, adding three new stations. At the same time, while the central station's apparatus remained horse-drawn, the newly built outlying station's apparatus was motorized. Eventually the remainder of the horse-drawn apparatus was replaced, and by 1918, the whole department was motorized. At least one of the horse-drawn ladder trucks was retrofitted with a tractor and remained in service many more years. By 1929, the department consisted of 10 fire stations.

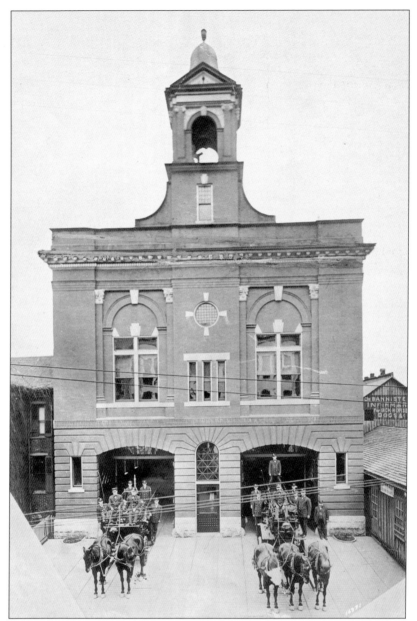

In 1912, a new Fire Station No. 1 was built at 13 Church Avenue SW in downtown Roanoke. This station replaced the former Fire Station No. 1, which was located at Jefferson Street and Kirk Avenue. The new firehouse was built in 1906 and opened in 1907. The bell from the original station was moved to this station and remained in the bell tower until being removed in 2002. This station is still open and operating after a century of service. The hose wagon (left) and ladder truck were both horse-drawn at the time. William T. "Bill" Jennings is driving the engine, and Capt. Carper Cleveland "Kinky" Meador is sitting next to him. The driver of the ladder truck is William J. "Pappy" Sink; Capt. Joseph Crockett stands next to him. W. G. Tucker stands next to the ladder truck. (Courtesy of Norfolk and Western Historical Photograph Collection, (NS 5802), Digital Library and Archives, University Libraries, Virginia Polytechnic Institute and State University.)

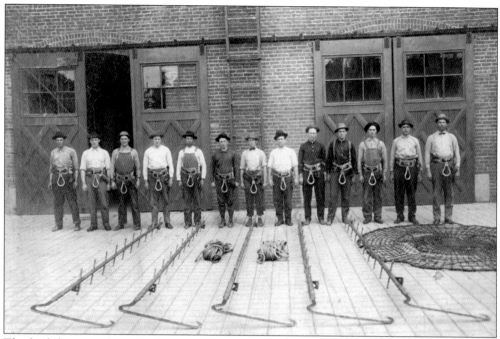

The firefighters are shown in the rear of Fire Station No. 1 posing with their equipment. The men have ladder belts around their waists and pompier ladders and a life net lying in front of them. The ladder belts are still used today and look similar to the ones worn here. Pompier ladders were used to climb a building from one window to the next, and the life net was used to catch a falling victim. For safety reasons, neither of these tools is used in the fire service today. (RFFA.)

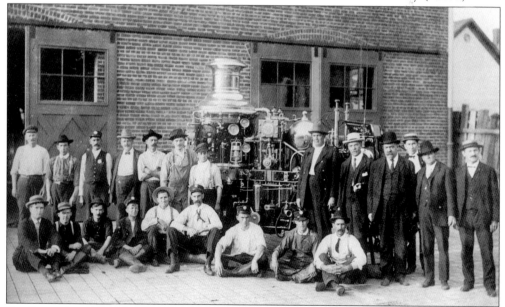

On September 5, 1907, the firefighters tested the first-size continental steam engine at Greene Memorial United Methodist Church. The test was to show that the steamer could shoot a stream of water to the tip of the steeple and prove it was capable of protecting the city. The steamer passed the test, and then the men gathered behind Station No. 1. (RFFA.)

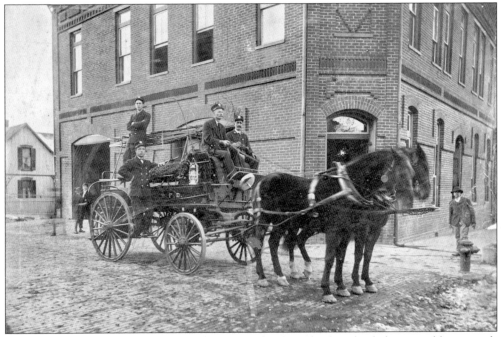

Capt. J. R. Bean (left) and Joseph C. Wade are seated on the fire chief's horse and buggy with two unidentified firefighters standing behind them at Fire Station No. 2 in 1918. This station housed a horse-drawn hose wagon and a reserve hose wagon. (HMWV.)

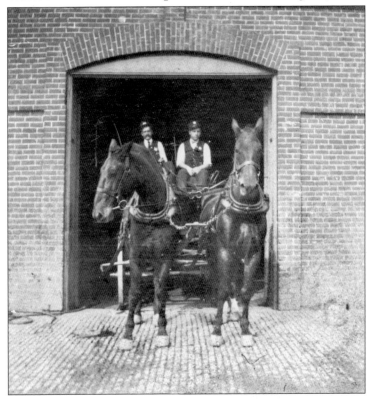

Capt. J. R. Bean (left) and Joseph C. Wade sit atop a horse-drawn fire wagon at Fire Station No. 2. Bean was one of the first paid firefighters in Roanoke, referred to as "regular men" in 1903. (HMWV.)

Joseph Wade washes the horses at Station No. 2. The horses were very well taken care of by the firefighters. Horses worked shifts, being put in a nearby pasture to rest after their shift in the fire station. (HMWV.)

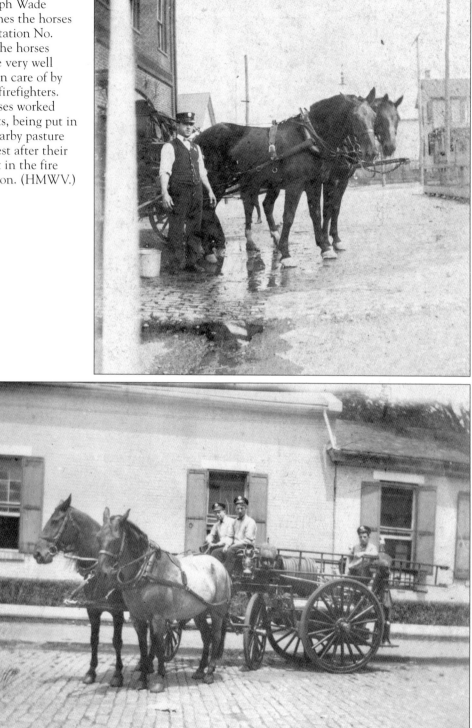

The horse-drawn straight chemical wagon housed at Station No. 1 carried two 75-gallon chemical tanks. (HMWV.)

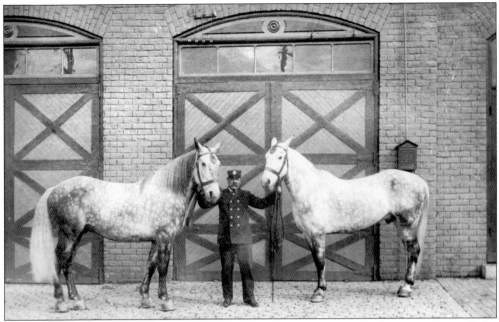

A firefighter poses in front of the original Station No. 1 with two of the horses used to pull the fire apparatus around 1903. Vigie was the name of the first fire horse in Roanoke, aptly named after the Vigilantes to whom the horse belonged. The firefighter is probably one of the paid engineers (drivers). In a new ordinance, which came out on February 4, 1903, the city decided to pay 22 men. The firefighters were paid $45 per month, engineers would receive $60, and the chief would receive $75 per month. Twelve of the men were full-time, and the other 10 were on call. These men continued to be supplemented by the volunteers. (RFFA.)

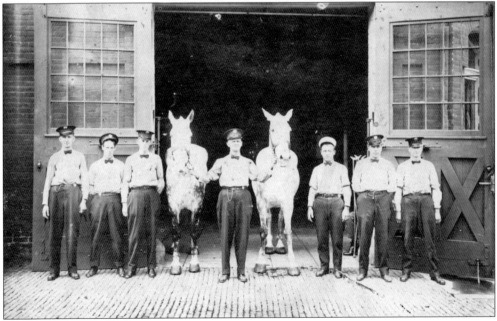

John C. Gregory (center) stands with other firefighters and the horses in front of Fire Station No. 2, located at East Street and Fourth Avenue. (RFFA.)

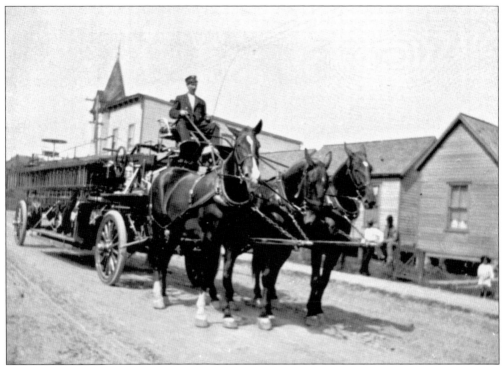

William J. "Pappy" Sink drives this Troika hook-and-ladder truck, which was put into service in 1909. Several years later, this truck was given a motorized tractor to replace the three horses. The truck would stay in service until 1938, when it was finally replaced. (HMWV.)

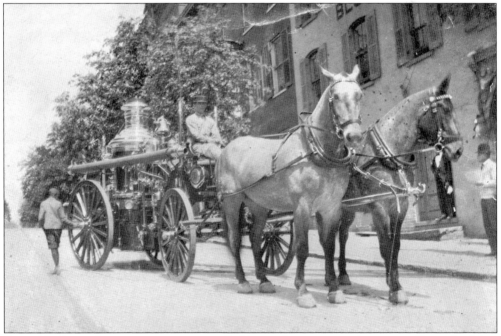

One of the horse-drawn steamer engines pulled by two horses sits on the streets of Roanoke. Note the trolley tracks running up the street. (HMWV.)

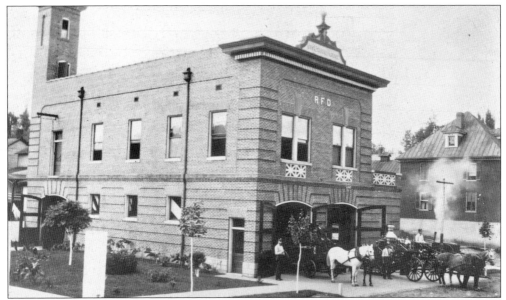

The second Fire Station No. 3 was opened on April 12, 1909, at 301 Sixth Street SW. The chemical wagon (left) and steam fire engine sit in front of Fire Station No. 3 ready to respond on emergencies. (Courtesy of the Virginia Room, Roanoke Public Libraries.)

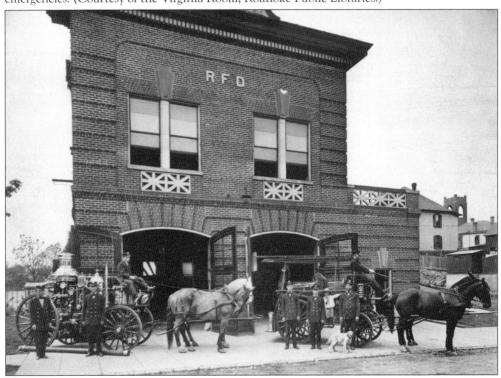

The steam fire engine is on the left, and the chemical hose wagon is on the right at Station No. 3. The station remains open today as a working fire station, although when the new fire station is opened at the northeast corner of Franklin Road and Elm Avenue, this will close down, and the apparatus will move to the new station. (RFFA.)

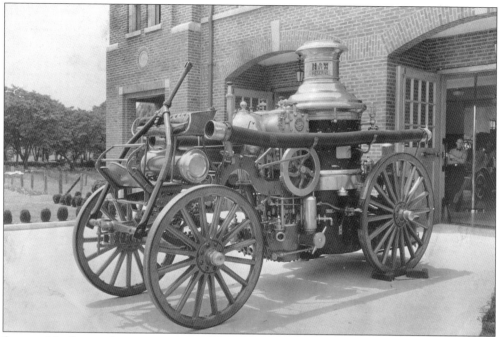

Steamer No. 2 was a first size continental engine and was placed in service September 1907. The steamer was bought by the Norfolk and Western Machine Shops and built by Ahrens Fire Engine Company in Cincinnati, Ohio. (RFFA.)

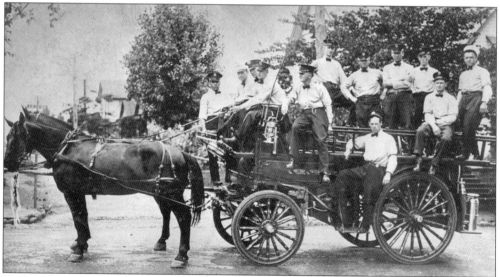

Hose Engine Company No. 1 poses at Fire Station No. 2 in the spring of 1916. The men from right to left are Joseph C. Wade, Frank W. Jennelle, R. Edward Barker, Capt. Eugene Brown Meador, Capt. Earl Charles Hawkins, B. H. Lanter, Capt. John Gregory, James E. Beard, Herbert S. Mills, Charlie H. Kelley, and Luther M. "Luke" Tyler. Larry W. Hawkins is standing on the front step. Joseph C. Wade left Roanoke to become a chief in the Miami Fire Department in Florida and was visiting when the picture was taken. B. H. Lanter was a firefighter in Miami Fire Department visiting as well. Until 1911, there were fire wagons and horses in each of the three Roanoke fire stations. (RFFA.)

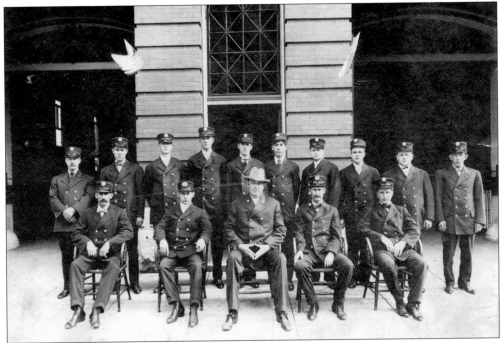

The firemen of Fire Station No. 1 pose for a picture along Church Street. The firemen, from left to right, are (first row) William Sink, Fredrick William Bladon, Chief James F. McFall, Stephen C. Snead, and Cleveland Carper Meador; (second row) Walter H. Via, James W. Nichols, Robert M. Hancock, George W. Witt, four unidentified, Edward H. Klinger, and Alfred N. Dent. (RFFA.)

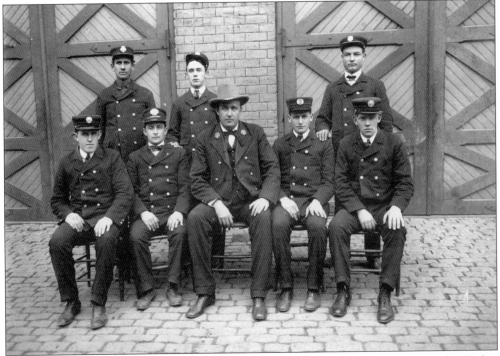

Chief James McFall (center) sits with the firefighters of the original Fire Station No. 1. (RFFA.)

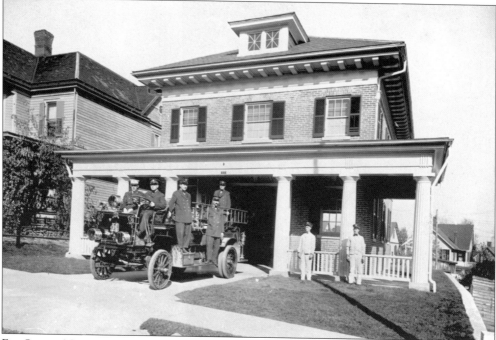

Fire Station No. 4 was opened on September 5, 1911, at 323 Highland Avenue SW housing Engine No. 4, a 1911 Seagrave. (HMWV.)

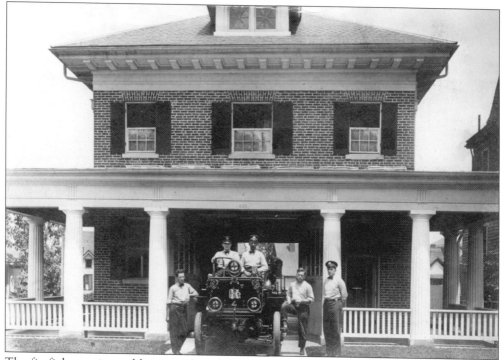

The firefighters pictured here are, from left to right, E. A. Stewart, W. L. Snead, William B. Johnson, Robert Hancock, and William Sink. This station was permanently closed on January 1, 1965, and was sold to Beth Israel Church. The building was later razed. (RFFA.)

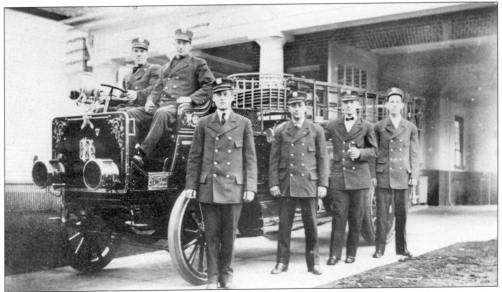

Here is a 1911 Seagrave engine. The chemical tanks were taken off these trucks when they were taken out of service and mounted on the walls inside the stations to hold Varsol. The firefighters used Varsol to keep the underside of the trucks clean for many years. (HMWV.)

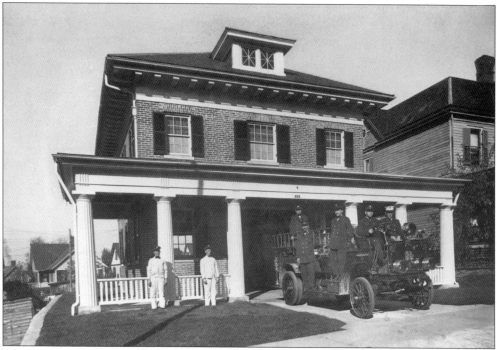

Fire Station No. 4 is shown soon after opening in 1911; by this time, there were a total of six stations. Three of the stations had automobile fire engines, and three had both horse-drawn hose wagons and steam engines. (Courtesy of Scott Boone.)

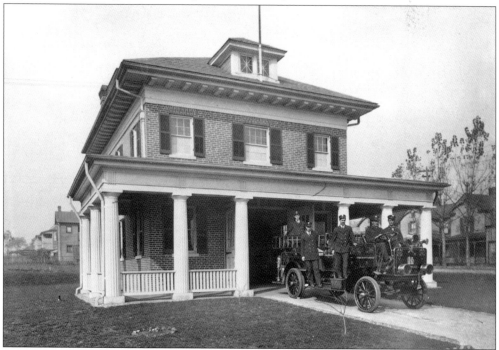

Fire Station No. 5 was opened on September 5, 1911, at 216 Twelfth Street NW housing Engine No. 5, a 1911 Seagrave. (Courtesy of Scott Boone.)

Fire Station No. 5 was opened to protect the citizens of northwest Roanoke. The station is the last of the three identical stations open today and houses one of the busiest engines in the city. (Courtesy of Willie Wines Jr.)

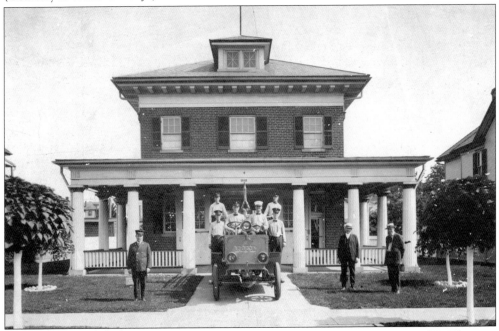

Fire Station No. 6 was opened on September 5, 1911, at 1015 Jamison Avenue SE. The men are, from left to right, (on the engine) Pete Eanes, Leroy "Lightning" Light (standing), Driver Edward Barker, Capt. John Gregory, Omer Thurman Johnson, and G. Lavon Creasey (standing); (standing in the yard) Chief Cleveland Meador (left), City Manager William P. Hunter, and a visiting fireman from Newport News, Virginia. The fire engine is a 1911 Seagrave with two 2.5-inch connections, one ½-inch nozzle, a 40-gallon chemical tank, 1,250-foot rubber-lined hose, a 24-foot extension ladder, and a 12-foot roof ladder. (RFFA.)

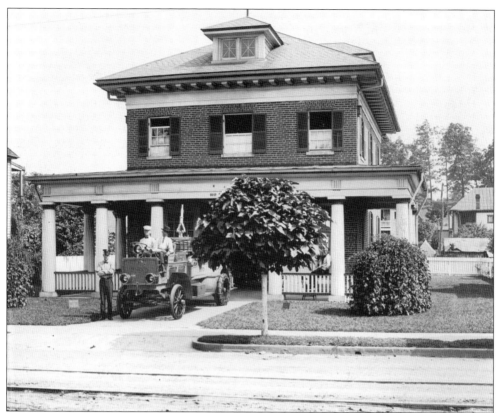

Wilson H. Bohon (left), John C. Gregory (center), and Joe Bush (citizen) appear in front of Fire Station No. 6 in 1922. (Courtesy of Bobby Bohon.)

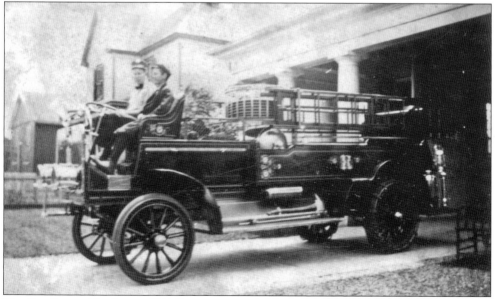

The first Engine No. 6 was a 1911 Seagrave, exactly like engines No. 4 and No. 5, which were all delivered at the same time. (RFFA.)

John P. Marshall stands with two women after Sunday school at Station No. 3. One of the women played the piano and the other directed and sang. For many years, Sunday school was held in most of the fire stations in Roanoke. Each of the stations had their own piano for this purpose. (RFFA.)

A firefighter poses with two of the horses. The horses were very well taken care of because the firefighters relied upon the horses to get the apparatus to the fire scene. The fire horses were not always on the calls. While some were kept in the stalls in the bays of the firehouses, others were in the pasture resting up for their turns. (RFFA.)

D. M. "Grover" Forbes (left) and Daniel G. Gillespie pose for their portrait. Forbes was hired January 1, 1910, and Gillespie was hired May 1, 1918. (RFFA.)

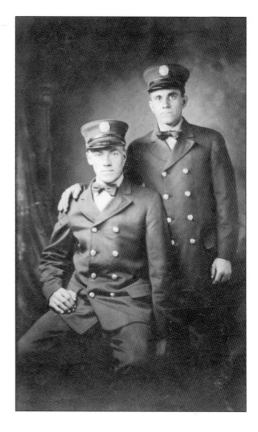

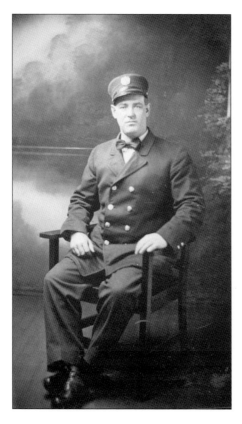

Earl Hawkins was hired on March 15, 1914, and retired March 5, 1944. Hawkins is dressed in the uniform of the day. The coat was usually removed for work. Eventually this uniform remained as the dress uniform, and a work uniform was instituted. The men wore the dress uniform to and from work, changing once they got to the station. (RFFA.)

Calvin E. "Pete" Shaver was hired on September 16, 1918, and retired January 1, 1947. Shaver stands in front of Fire Station No. 1. Shaver was promoted to the rank of captain of Engine No. 5 following the death of Capt. Jess M. Hancock. Shaver had been the lieutenant of Engine No. 6. (Courtesy of Bobby Bohon.)

James Harry Brogan was hired on January 1, 1917. The building behind him is the Bannister Infirmary for Sick Horses, Dogs, and Company. Ever since Fire Station No. 1 was built, there has been a building on the right side of it. (Courtesy of Bobby Bohon.)

C. W. Brammer (left) was hired on April 1, 1918, and Claude E. Meador on January 1, 1913. Claude was fired on February 21, 1920, when firemen went on strike because they wanted to unionize. The city manager warned 14 members who persisted about organizing, and they were discharged. The 14 firefighters included P. H. Brooks, C. A. Brooks, C. H. Eanes, William B. Johnson, Herbert S. Mills, Cecil C. Morris, C. E. Prillaman, and G. L. Turner. Three fire stations were closed down for an undetermined amount of time due to the lack of staffing. It is unclear whether or not any of those 14 firemen came back to work. It would be another 33 years before the firemen were finally able to organize with the International Association of Firefighters. The Roanoke Fire Fighters Association Local 1132 was chartered in 1953. (Courtesy of Bobby Bohon.)

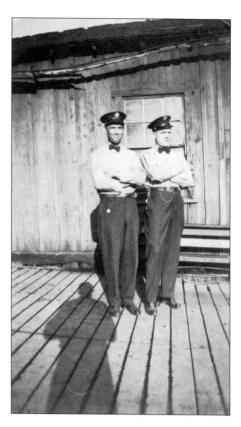

Walter L. Wheeler stands in front of Fire Station No. 1. Wheeler was hired on January 1, 1913. (Courtesy of Bobby Bohon.)

Wilson H. Bohon (left) was hired October 25, 1918, and retired on August 1, 1947. R. Herbert Mills was hired May 22, 1918. Bohon was the secretary at Station No. 1 for several years before being moved to Station No. 8. The men who were the secretaries usually kept that position for several years. These men ran calls just like all the other firefighters. (Courtesy of Bobby Bohon.)

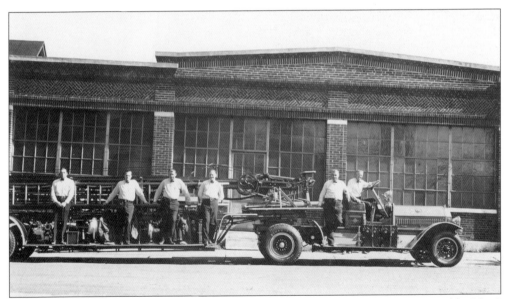

Ladder No. 2 was a 75-foot aerial ladder, built in 1909 as a horse-drawn apparatus. Ladder No. 2 was given a motorized tractor to pull the wagon just before 1920. This truck remained in service until 1938, when funds were set aside to replace it. Near the end of its career, the chief would only let the firefighters extend the truck to 55 feet. (RFFA.)

Victor Richard Metz was hired April 13, 1920, and retired August 20, 1953. The firefighters had professional portraits taken occasionally during their careers, much like the volunteers before them. This tradition remains today. (RFFA.)

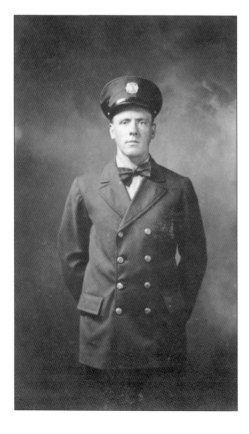

Herbert Mills was hired May 22, 1918. Mills was fired during the attempt to organize as a Local of the International Association of Fire Fighters in 1920. (Courtesy of Bobby Bohon.)

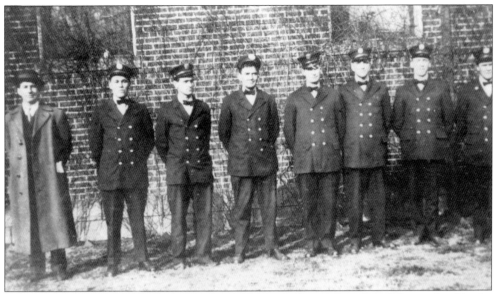

Firefighters stand in the side yard of Fire Station No. 3. The men are, from left to right, Charlie Craig, E. L. "Cricket" Craighead, Charles T. Ayers, Charlie Crouch, James Beard, John M. St. Clair, Harry Daniels, and Capt. L. Manning. (RFFA.)

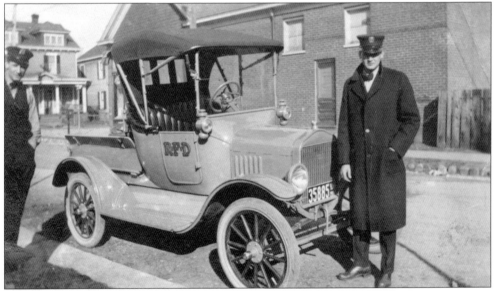

The first car of a Roanoke fire chief was a Model T Ford. Chief Cleveland Meador was sworn in on January 1, 1918, becoming the second chief of the Roanoke Fire Department. Chief Meador responded on the last alarm answered by a horse-drawn fire wagon at Box 52—Franklin Road and Third Street SW—on May 18, 1918. (RFFA.)

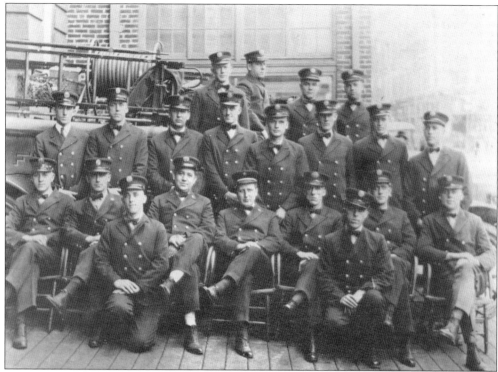

The men pose in front of Fire Station No.
1. A 1918 Seagrave Brasshead sits behind
them on the front apron of the downtown
fire station. (RFFA.)

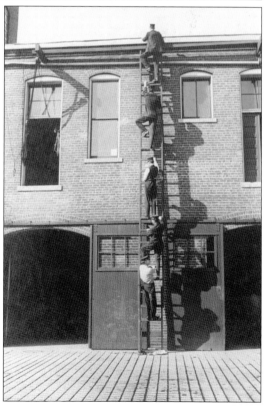

In the rear of Fire Station No. 1, the
men show the strength of the wooden
ladders. The wooden ladders of the day
have now been replaced with aluminum
ladders, which are lighter and require less
maintenance. The open doors on the
second floor were used as haylofts in the
time of horses. The metal I-beams can
still be seen on the rear of the fire station
where the pulleys were attached. (RFFA.)

Bulletin To Members

New York, November 1st., 1919.

Having finished my work as General Fire and Guard Marshal of The Emergency Fleet Corporation and accepted a position with The West Penn Power Co. of Pittsburgh, work totally removed from the Fire Service, I have resigned to President Kenlon my position as Secretary. In severing my connection with the association, after fifteen years of service as your Secretary, I wish to express to each and every one of you my very great appreciation for your long and continued support and favors. I shall always carry with me a heart full of love for you. May you all live long and prosper, is the wish of

Yours Fraternally,

James McFall

My new address:
P. O. Box 1223
Pittsburgh, Pa.

This is a correspondence from Chief James McFall when he stepped down as secretary of the International Association of Fire Chiefs in 1919, a position he held since 1905. James McFall was a charter member of the Junior Hose Fire Company and was assistant chief of the fire department under J. G. Knepp in 1892 and 1893. He was elected chief January 1, 1894, and later became the first chief of the paid Roanoke Fire Department. (RFFA.)

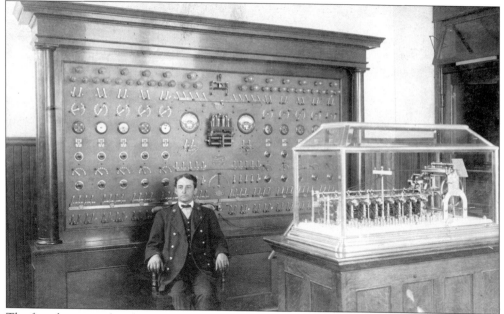

The fire alarm panel and repeater system were housed at Fire Station No. 1 for many years. The department had their own electricians who took care of the alarm system and fire alarm boxes. The electricians were Fred Bladon (the first until 1918), George Witt (1916–1922), Bill Kirnan (1922–1925), William Mullins (1925–1930), and Guy L. Austin (1930–1965). After 1965, the communications department took over the alarm system, although Carl C. Holt was considered the department electrician in 1965. The repeater system can still be seen at Station No. 1. (RFFA.)

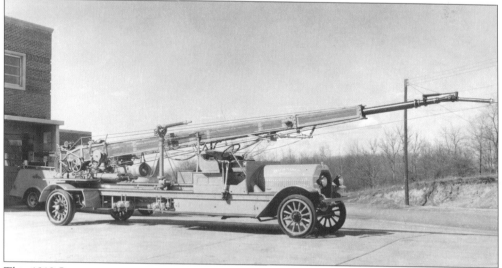

This 1918 Seagrave water tower was purchased for the Roanoke Fire Department by the Norfolk and Western Railway, and it is believed that the purchase was prompted by the 1896 Norfolk and Western general offices' fire, 22 years prior to the truck's construction. The water tower was in service in Roanoke from 1918 until the mid-1950s. The truck remained original with wooden wheels and solid rubber tires, boasting 79 horsepower, a 55-foot boom, and chain-driven rear wheels. This water tower was one of only about 130 of its kind built in the United States. In 1956, near the end of its service, the truck had only 482 miles on it. (Courtesy of Michael Jenkins.)

In the summer of 1918, the Sunday school poses at Fire Station No. 6. Earl Hawkins is seated behind the wheel of the fire engine, and at his right is his son, Leslie. Sunday school was held at many of the fire stations for many years. (RFFA.)

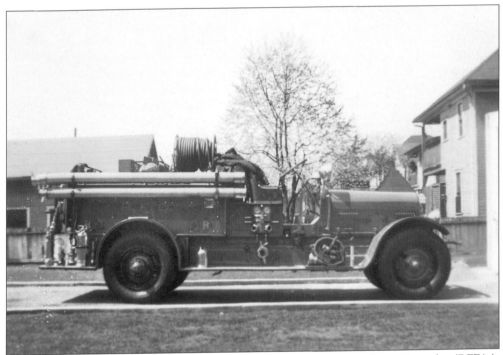

Engine No. 6, a 1929 Seagrave, sits out behind Fire Station No. 6 in southeast Roanoke. (RFFA.)

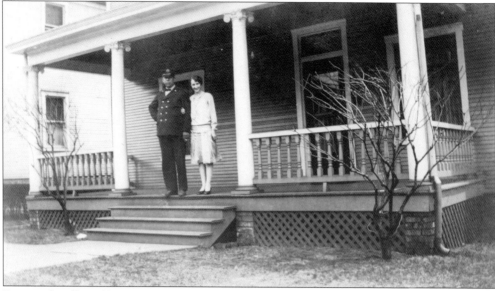

Raymond Wills and his wife, Sadie, stand on their front porch in 1927. Raymond, who was hired on March 1, 1916, and retired on March 1, 1946, fought in World War I and returned to work afterward. (RFFA.)

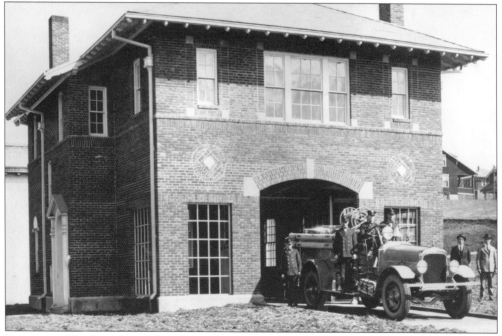

Fire station No. 7 was opened on December 13, 1922, at 1742 Memorial Avenue SW. When the station was built it housed engine No. 7. This is the first engine No. 7 which was a 1922 Seagrave engine. The firefighters are, from left to right, Howard W. Bright, Capt. John T. Allman, Engineer William M. Bracy, and Andrew L. Hackworth. Doc K. Kennett was also assigned to the station but was absent that day. In 1950, the city decided to add an additional bay on to station No. 7 to house a ladder company. The firemen who were assigned to the station did most of the work in building the addition. (RFFA.)

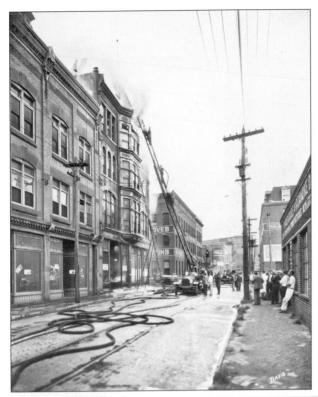

The Philip Levy and Company furniture store caught fire twice in two years. The first, on October 8, 1927, was minor, and they were able to reopen soon afterwards. The second fire, on August 31, 1928, would prove to be more of a challenge for the firefighters. The building was located at 118 West Salem Avenue at the corner of Roanoke Street. (Courtesy of the Virginia Room, Roanoke Public Libraries.)

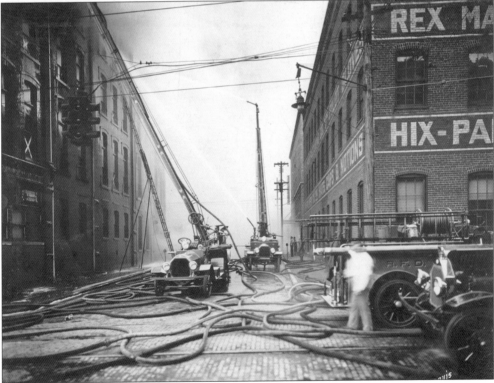

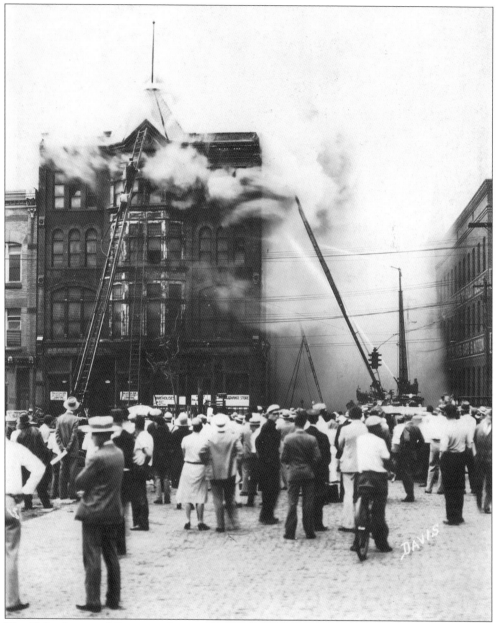

The Philip Levy and Company furniture store alarm was struck at 1:21 p.m. on August 31, 1928. Firefighters utilized both ladder trucks' extension ladders to reach the fire that was burning in the top floors of the four-story building. (RFFA.)

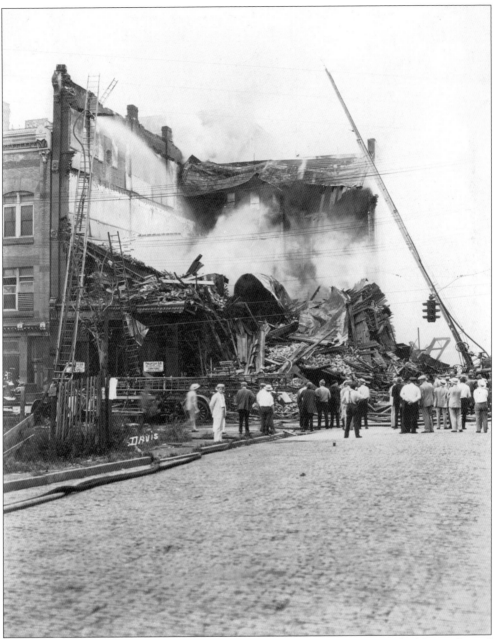

After two hours of heavy damage from the fire, the Philip Levy and Company building collapsed around 3:30 p.m. When the building fell, the debris damaged one of the ladder trucks, the water tower, and the chief's car. Fortunately only one firefighter was injured. Ralph R. Daniel was injured during the collapse and transported to Lewis Gale Hospital. The injury was not debilitating, and Ralph went on to retire in 1951 after 30 years of service. (RFFA.)

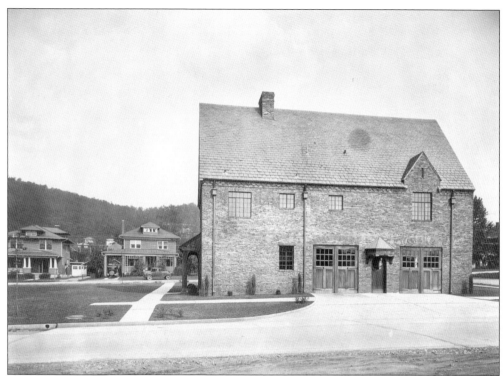

On January 23, 1929, at 11:00 a.m., the new Crystal Springs Fire Station No. 8 opened its doors. The station opened with eight men assigned and remains open as a landmark fire station today. (Courtesy of the Virginia Room, Roanoke Public Libraries.)

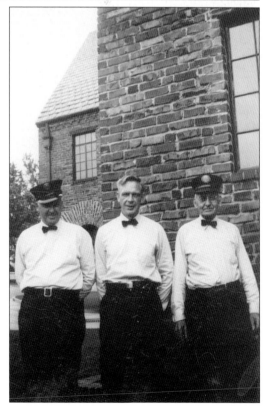

Charles Warren Wells (left), John Oakey Mullins (center), and Charlie Crouch stand outside of Fire Station No. 8. (RFFA.)

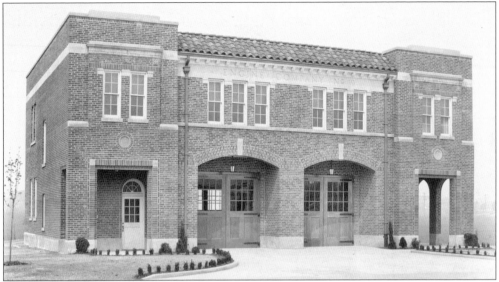

On October 2, 1929, at 5:00 p.m. the Villa Heights Fire Station No. 9 was opened at 514 Twenty-fourth Street NW. The station was opened with eight men housing one engine company and cost $10,800 to build. (Courtesy of the Virginia Room, Roanoke Public Libraries.)

The Hotel Ponce De Leon caught fire on December 28, 1930. All nine engines and two ladder trucks from Roanoke City were on the scene of the fire, including a hose truck from Vinton and an engine from Salem. It was estimated that four million gallons of water were used to extinguish the flames. The damage was estimated at $600,000. A local gentleman, W. S. Trace, was the only victim of the fire. During the fire, another alarm came in at 806 Park Street NW. The alarm ended up being a fire in a residence, and the structure was practically destroyed. The remainder of the Vinton Fire Department was needed to handle that fire. (RFFA.)

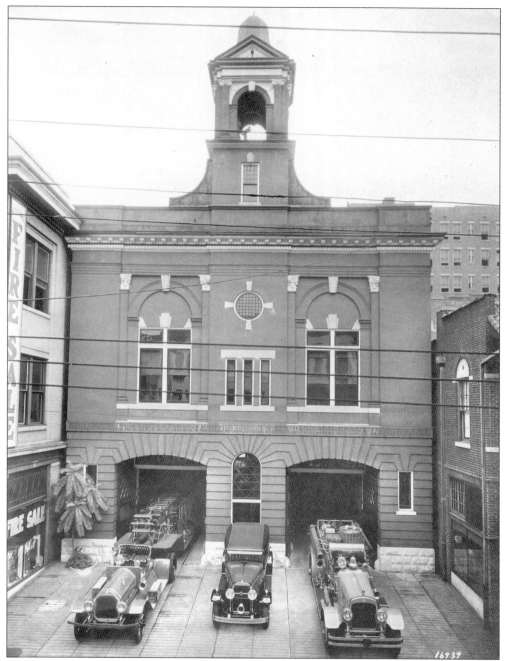

Pictured at Fire Station No. 1 located in downtown Roanoke in 1932 are Ladder No. 1 (left), the chief's car (center), and Engine No. 1. (Courtesy of Norfolk and Western Historical Photograph Collection, (NS 5683), Digital Library and Archives, University Libraries, Virginia Polytechnic Institute and State University.)

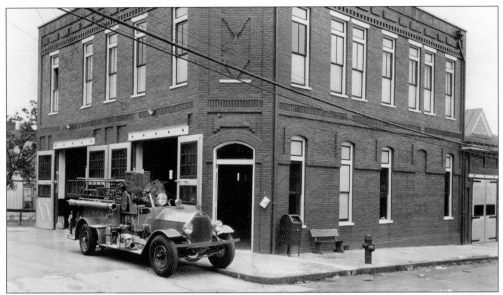

Fire Station No. 2, located at East Street and Fourth Avenue, was originally built as Fire Station No. 3 for the Friendship Fire Company. The station was renumbered after the department went to a fully paid force in 1907. Before the 1920s, the firehouse's facade was removed across the roof line. This station was taken out of service in the early 1950s when Fire Station No. 10 was built on Noble Avenue (now Fire Station No. 2). (RFFA.)

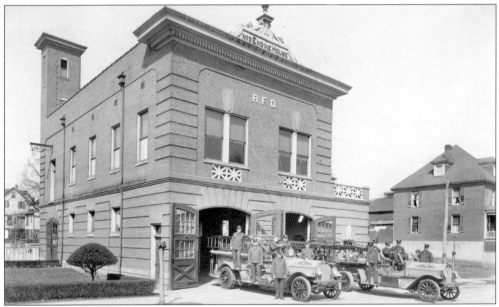

In the 1920s, Engine Company No. 3 (left) was a 1920s Seagrave Brasshead and Ladder No. 2 was a 1920s-model Seagrave. In 1956, the city added a communications room to Station No. 3. The room was fireproof and was built onto the side of the building. The communications equipment was the most modern in the country at the time and replaced the outdated equipment at Fire Station No. 1 that was installed in 1907. The firemen helped keep the cost of the construction down by building the entire addition themselves. (Courtesy of the Virginia Room, Roanoke Public Libraries.)

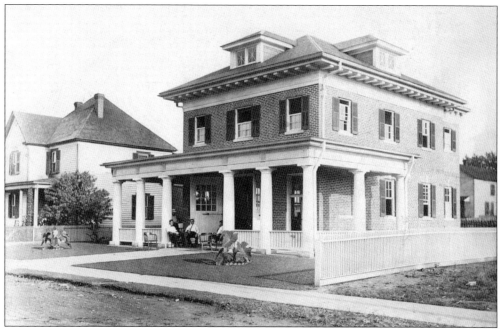

Fire Station No. 6 was closed down on January 2, 1979, and was turned into a community center. The station is now used as a police substation. Fire Station No. 6 was added to the Virginia Landmarks Register on April 17, 1990, and the National Register of Historic Places on January 24, 1991. (RFFA.)

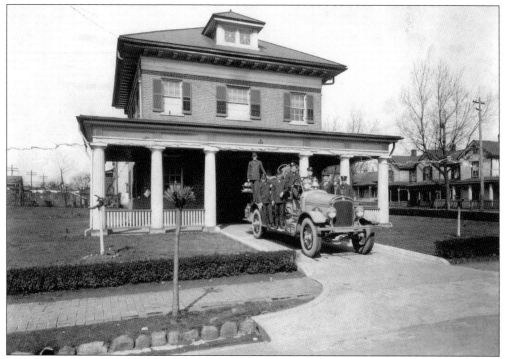

This 1928 Seagrave engine is parked in front of Station No. 5. The Roanoke Fire Department was almost completely a Seagrave fleet until the 1940s. (Courtesy of Willie Wines Jr.)

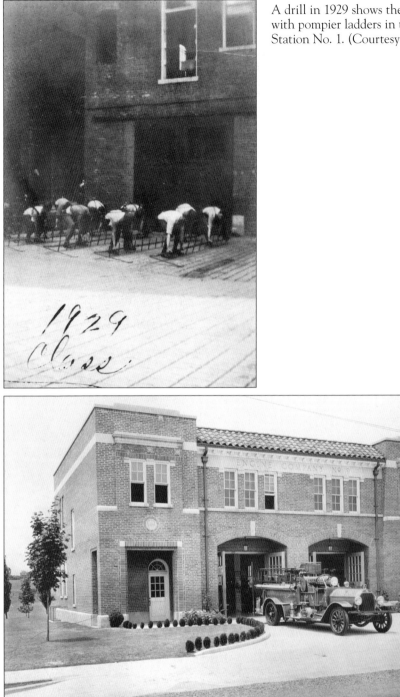

A drill in 1929 shows the men training with pompier ladders in the rear of Fire Station No. 1. (Courtesy of David Wray.)

Fire Station No. 9 was opened on October 2, 1929, at 514 Twenty-fourth Street NW. When the station opened, it housed Engine No. 9. Several years later, Ladder No. 9 was added. The ladder truck was moved to Station No. 13 in 1998 and Medic No. 9 was put in its place. Fire Station No. 9 remains open and relatively unchanged since being built. (RFFA.)

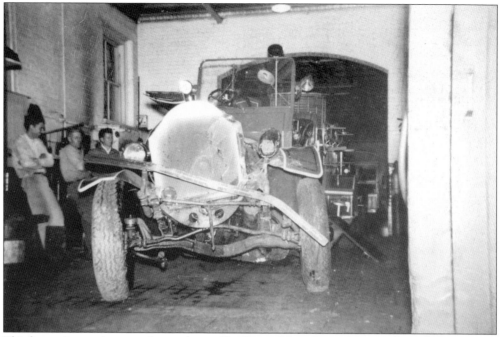

This fire engine was in an accident and sits in Fire Station No. 1. Station No. 1 is where all the apparatus were maintained. Some apparatus were even built inside the bays by firefighters. (RFFA.)

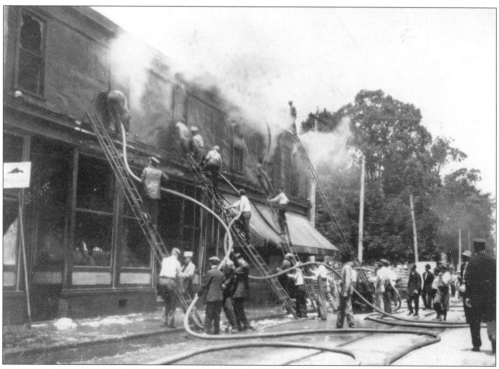

Roanoke firefighters fight an unknown fire in downtown Roanoke. Note the lack of turnout gear and the use of the wooden ladders. (RFFA.)

Chief Cleveland Meador and a group of firefighters stand behind a fire station. Many fire stations had a dog that stayed around and was kept as a mascot. A tragic story still told at fire stations describes events during the years of horse-drawn apparatus. During this time, there was a dog at Fire Station No. 2 that would answer every call with the firemen. Usually the dog would hop on the hose wagon with the firefighters when the alarm sounded. On one occasion, the company was away from the station and the dog was by itself when the alarm came in. The dog left the station heading to the alarm; on the way, the horse-drawn hose wagon crossed paths with the dog and it was killed. Ironically the dog was going in the right direction to the proper alarm box, and the firefighters were going in the wrong direction. (HMWV.)

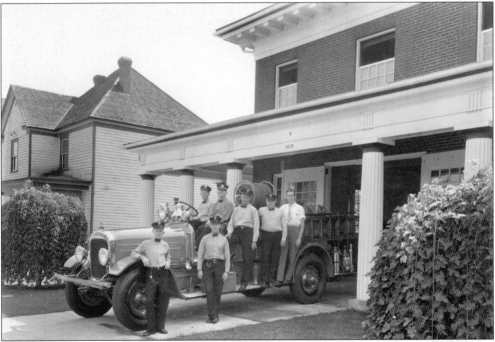

The men of Fire Station No. 6 in 1931 were, from left to right, (standing in front) James H. Carty and Gilbert "Turkey" Gobble, Edward Barker driving Capt. John Gregory, Lt. Alfred P. Britt, Edward Klinger, and Sidney Whit Vaughan. (RFFA.)

The men of Fire Station No. 8 in the late 1920s were, from left to right, John Mullins, Wilson Howard "Hotshot" Boitnott, Capt. Charles Wells, and Engineer Daniel Price Flora. (RFFA.)

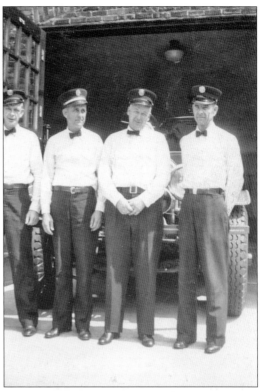

The men of Fire Station No. 1 in the 1920s were, from left to right, James Snead, ? Crews, Raymond Wills, Harry Daniels, Ralph R. Daniel, Jim Nichols, and Cleveland Meador. (RFFA.)

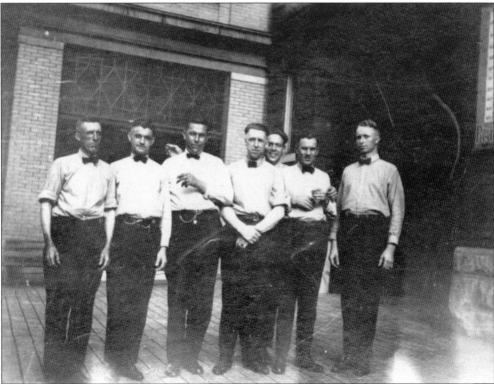

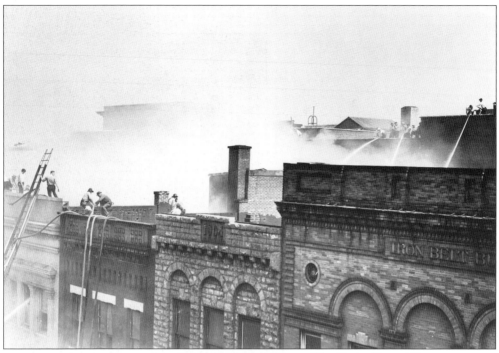

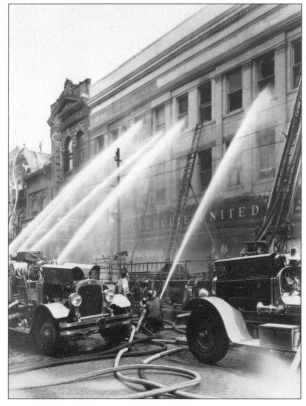

The Shulte United Department Store caught fire on July 8, 1933, at 16 West Campbell Avenue. Engine Companies No. 1, 2, 3, 4, 5, 6, and 8; Ladders No. 1 and No. 2; as well as No. 3 engines from Salem and Vinton fought the blaze. Engines No. 7 and No. 9 continued to run other calls as the only apparatus not on the scene of the fire. (RFFA.)

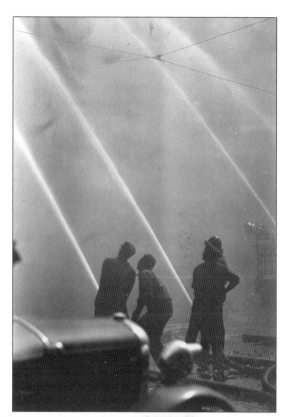

The entire third floor of the Shulte United Department Store was consumed by flames, and most of the roof burned off. Six firefighters were injured when they were overcome by smoke from the fire. (RFFA.)

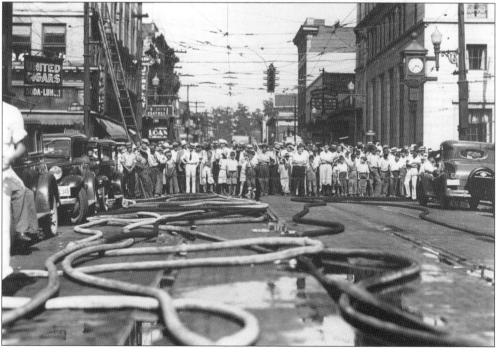

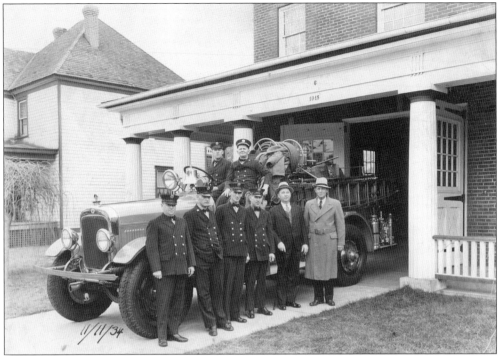

The men of Fire Station No. 6 pose for a picture in 1934. The firemen are, from left to right, Edward Klinger, Calvin Shaver, W. Demutris Musgrove, Howard Boitnott, Peter Parrish, and Edward Barker. The men sitting on Engine No. 6 are Engineer Gilbert Gobble (left) and Capt. John Gregory. (RFFA.)

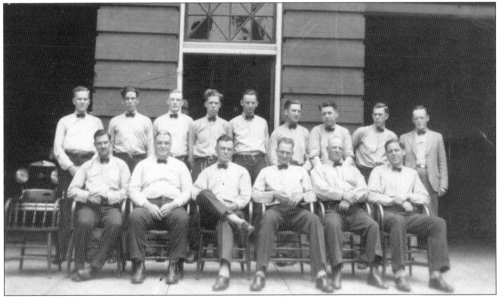

The men sit in front of Fire Station No. 1. The men are, from left to right, (first row) Edward E. Kane, Michael "Mike" S. Fealey, Alfred Britt, Denton "Andy" Lewis Brubaker, Earl Hawkins, and Ralph Daniel; (second row includes) Jim Nichols, Eslie J. Knowles, Cornelius "Neil" Curtis Brubaker, Marshall "Scorchy" W. East, Harry Daniels, James Roy Boitnott, and Sam A. Wright. (RFFA.)

Firefighters battle a fire at the Park Street Office Building on March 1, 1934. (Courtesy of Norfolk and Western Historical Photograph Collection, (NS 5689), Digital Library and Archives, University Libraries, Virginia Polytechnic Institute and State University.)

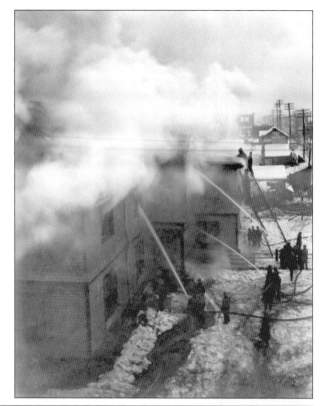

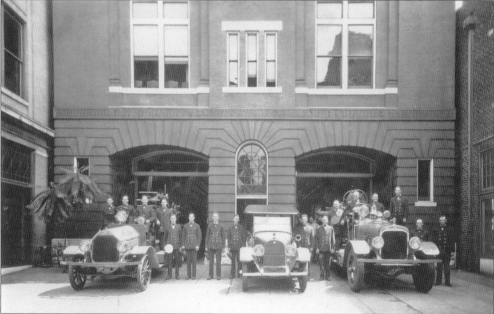

On October 9, 1934, Pres. Franklin D. Roosevelt came to the Roanoke Valley to celebrate the opening of the Salem Veterans Affairs Medical Center. While in town, President Roosevelt took the time to stop by Fire Station No. 1 and meet the firemen. In Engine No. 1 (right), the president can be seen sitting in the officer's seat (left). (Courtesy of Willie Wines Jr.)

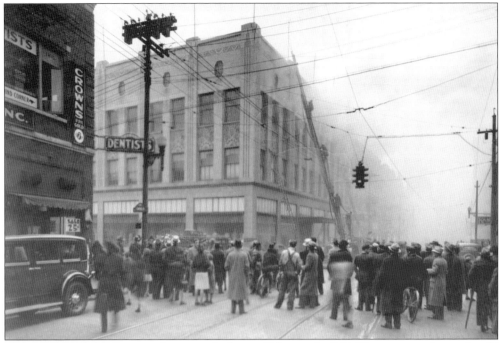

The N. W. Pugh Department Store caught fire on February 3, 1935. The store was located at 35 West Campbell Avenue. All but two of the city's fire apparatus responded to the fire. (Courtesy of the Virginia Room, Roanoke Public Libraries.)

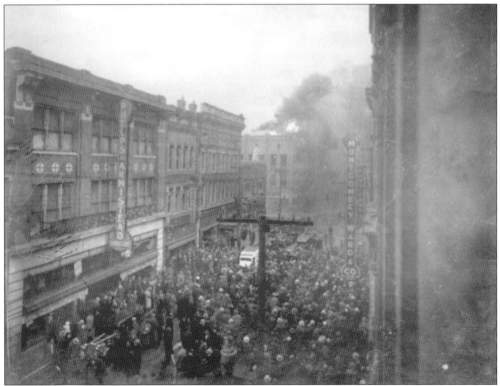

Three

THE SECOND PLATOON

On July 1, 1936, twenty men were hired to form a second platoon. Over 500 applications were accepted, although many were rejected due to the restrictions of having to weigh 150 pounds and be a registered voter in the city of Roanoke. The addition of the second platoon cost the city $26,000. This restructuring of the fire department created two shifts. The men worked every other day and received three "Kelly" days each month. The Kelly days were extra days off and were picked by seniority each month.

On March 3, 1935, the Roanoke Firemen Federal Credit Union was chartered. The firefighters created the credit union to borrow money for their uniforms and pay it back in small payments. At that time, their uniforms and gear cost around $500.

In 1953, following 30 years of unsuccessful attempts, the firefighters organized the Roanoke Fire Fighters Association Local 1132, a chapter of the International Association of Firefighters. Finally the firefighters had a collective voice, ensuring decent working conditions, pay, and benefits.

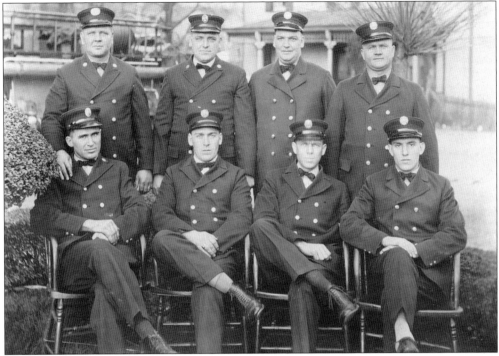

Firefighters pose at Station No. 3 in 1936. The men are, from left to right, (first row) Capt. Grover W. Craddock, Engineer Gilbert Gobble, Frank R. Barnette, and unidentified; (second row) Captain Stevens, Claude Meador, Michael Fealey, and Dock O. Stevens. (RFFA.)

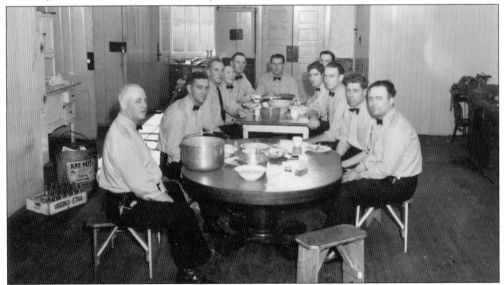

The firemen of Fire Station No. 1 enjoy supper in 1940. Although the eating area has been remodeled since, Fire Station No. 1 remains open as a working fire station. It is considered the oldest working, fully paid fire station in Virginia. The firemen are, from left to right, Earl Hawkins, Charles R. Nolley Sr., James Nichols, William B. "Foots" Barker, Edward Barker, Ernest S. "Jake" Burford, Daniel Ralph Sink, Leonard M. Black, Maynard C. Peters, Eslie J. Knowles, and Earnest E. Ferguson. (RFFA.)

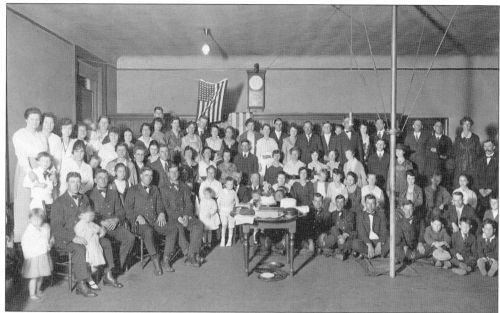

Several Roanoke firefighters were drafted to fight in World War II in the spring of 1942. The firefighters being sent to war were given a send-off reception in the upstairs of Fire Station No. 1. (RFFA.)

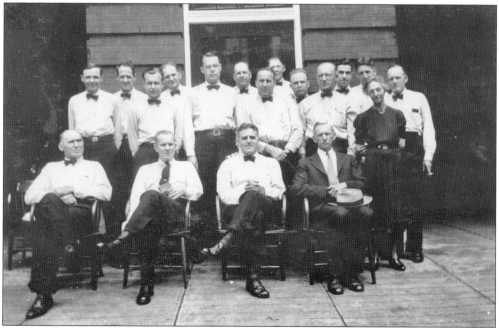

The men pose in front of Fire Station No. 1 in May 1943. The men are, from left to right, (seated) Capt. Grover Craddock, Assistant Chief James Nichols, Early McKinley "Mickey" McGuire, preacher ? Altizer, and Mrs. Speese (the piano player for Sunday school); (standing) Garvey M. Jordon, Charlie C. Kane, Elmer Elijah "Pete" Smith, Denton Brubaker, Johnnie J. Falls, Levi Edward Jamison, William Revone "Sweet Willie" Bolling, William Barker, Robert Gillespie, Walter Via, Luther Kingery, Harry Daniels, and Sam Wright. (RFFA.)

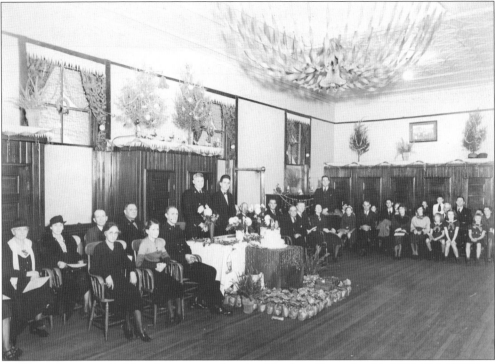

A Christmas party is held in the upstairs of station No. 1 on December 20, 1935. Chief William Mullins (left) and Wilson Bohon stand and address the crowd of firefighters and their families. For many years, this bedroom was used to host a variety of social functions. (RFFA.)

From left to right, Ralph Sink, Assistant Chief James Nichols, Eslie J. Knowles, Marion ?, Earl Hawkins, and Earnest Ferguson pose on the engine at Station No. 1 downtown. (RFFA.)

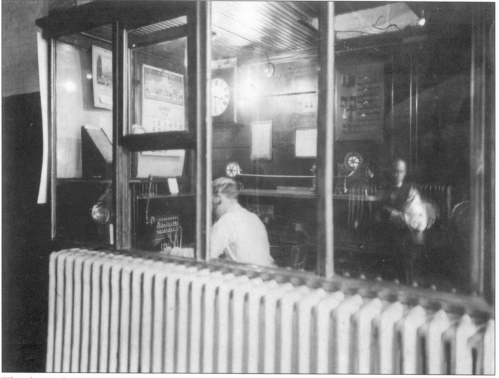

The dispatch center was in the bay of Fire Station No. 1 for many years. This room was located just inside the right side bay door. (Courtesy of Willie Wines Jr.)

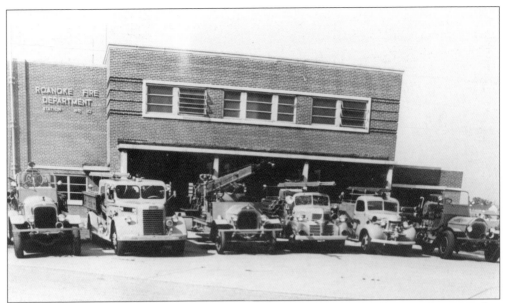

Fire Station No. 10 was opened in 1950 at 55 Noble Avenue NE. This station is still open today, although it was renumbered to No. 2 when the new Fire Station No. 10 was opened in 1974 at Roanoke Regional Airport. The apparatus from left to right are a 1920s Seagrave Brasshead, a 1950 Oren, a 1918 Seagrave Watertower, a 1940s Dodge, a 1940s Chevrolet, and a 1918 Seagrave Brasshead. (RFFA.)

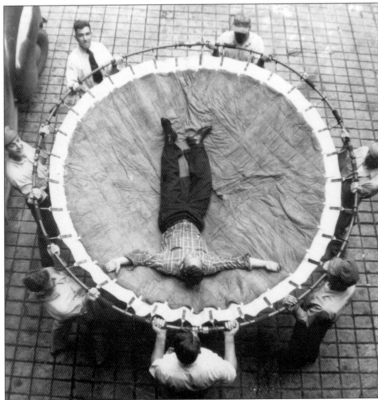

The men of Fire Station No. 1 jump out of the hayloft into a jump net. This exercise was a rite of passage dating back to when the station was built in 1907. Although the doors for the haylofts are still on the second floor of the station in the rear, the hay is long gone. (RFFA.)

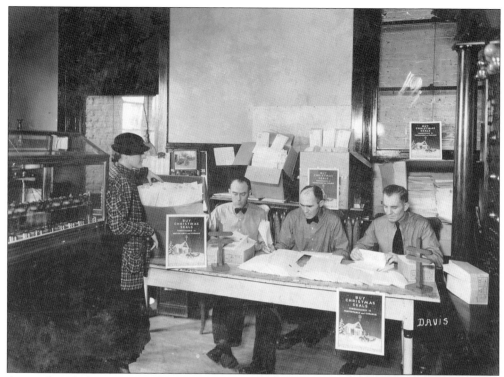

An unidentified woman purchases Christmas Seals from the firefighters in the chief's office at Fire Station No. 1. The men from left to right are William H. "Jerry" Jennings, Grover Craddock, and James Nichols. The Christmas Seals were being sold to benefit the Roanoke Tuberculosis Association (RFFA.)

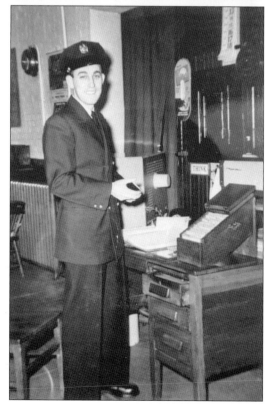

Robert Norman Guthrie was hired March 16, 1950, and retired March 27, 1990. Guthrie is standing at the captain's desk of Fire Station No. 6. (RFFA.)

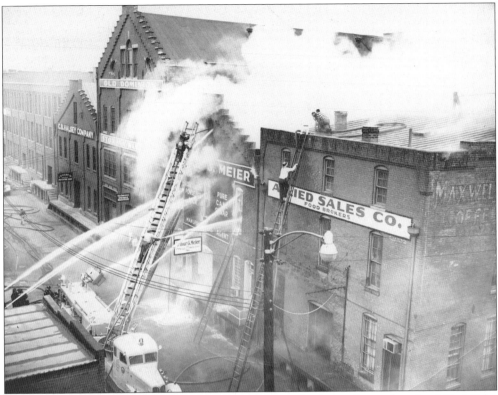

On April 29, 1955, the Arthur G. Meier Warehouse caught fire and spread to the Allied Sales Company located on Wholesale Row on Norfolk Avenue. The first call came into city hall at 4:38 p.m. and utilized most of the department's apparatus. One of the engines was even pumping water out of one of the building's basements back onto the fire. (Courtesy of Jimmy Poindexter Jr.)

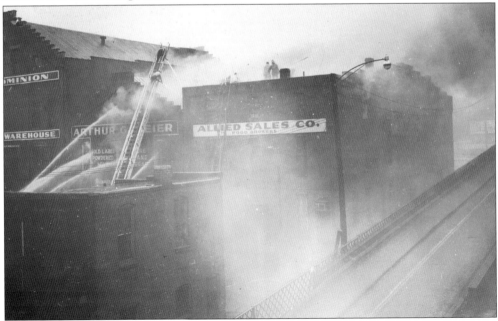

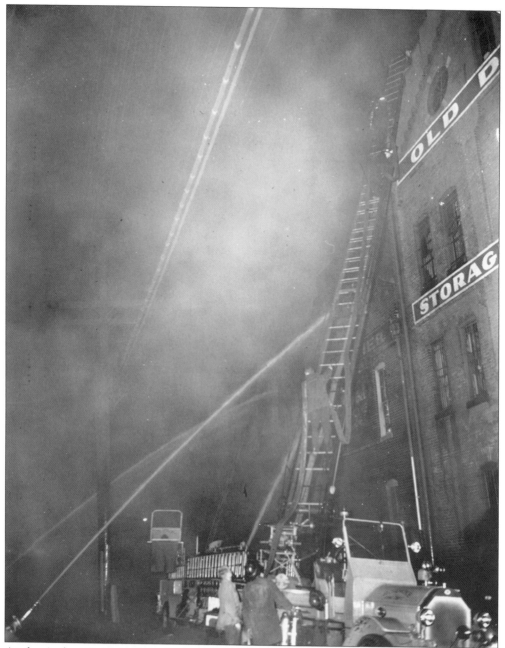

At the Arthur G. Meier fire, the firefighters pumped an estimated 1,800,000 gallons of water into the buildings. Off-duty firemen were called in to help with the biggest fire the department had experienced since 10 years prior. In all, 115 of the 129 firemen in the department fought the blaze, which kept them busy until around midnight. The loss due to the fire was estimated at being over a half-million dollars. (Courtesy of Jimmy Poindexter Jr.)

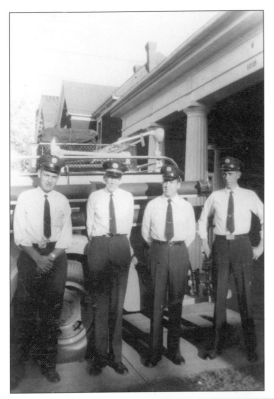

The firefighters stand out in front of Station No. 6. The men are, from left to right, Irvin E. Young, Capt. William Barker, Engineer John Wiley Shepherd, and McCoy Mills. (RFFA.)

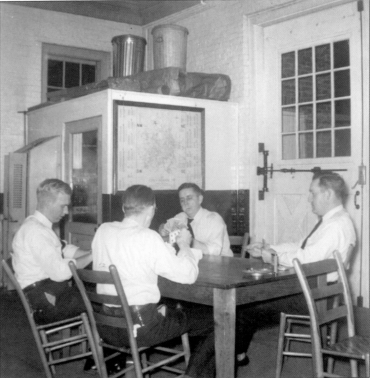

The firefighters take a break from work to play cards at Station No. 6. The men are, from left to right, Irvin Young, Capt. William Barker, Robert Clinton Breeden, and Edward Alexander "Pollard" Thompson. (RFFA.)

Four

THE DIAMOND JUBILEE

In 1957, Roanoke City celebrated the Diamond Jubilee, marking 75 years since being chartered. Roanoke was decorated all around with flags and banners for the Diamond Jubilee. The event featured a parade that passed through downtown Roanoke. While it may be near impossible today, in 1957, the entire fire department was captured through a series of photographs. The two shifts were pictured together at each of the 10 stations. The beginning of this chapter features these photographs with the exception of Station No. 6.

The firefighters were ordered to grow facial hair for the Diamond Jubilee. The men grew mustaches, goatees, and beards. If the men did not comply, they were fined and the money was taken out of their paycheck.

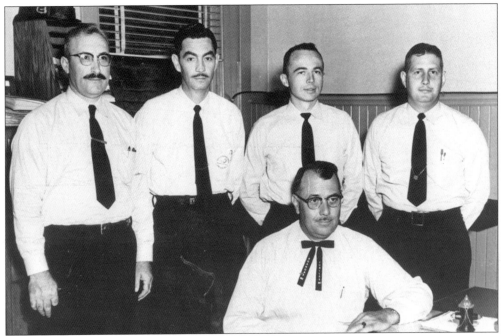

Chief John Verlie Brown sits in the chief's office of Fire Station No. 1 in 1957. The men standing behind him are, from left to right, Staff Capt. Alfred "Fred" K. Hughson, Raymond Mills, Robert C. Poole, and Staff Capt. Clayton D. Sink. On the shelf behind the men, there is an old high eagle-front leather helmet adorned with No. 2 for the Junior Fire Company No. 2. Around the helmet sits a leather belt also adorned with the No. 2. These items were remnants of the Volunteers from 50 years prior. This chief's office is now used as the battalion chiefs' bunk room. (RFFA.)

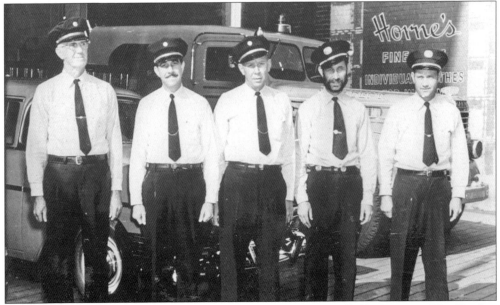

Pictured from left to right, Fire alarm electrician Guy L. Austin (left), Assistant Chief Luther C. Kingery, Assistant Chief Eugene Meador, Senior Mechanic Engineer Charlie E. Laprad, and Mechanic Engineer Loyd R. Padgett stand in front of Station No. 1 on June 11, 1957. (RFFA.)

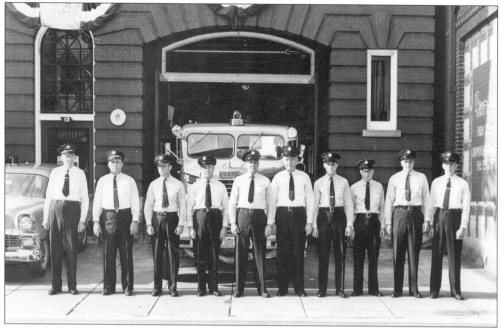

The firefighters of Engine No. 1 stand in front of Station No. 1 in 1957. The firefighters from left to right are Grover Craddock, Reginald J. "Pete" Morgan, Robert Gillespie, George Guill, John B. Ballantine, Irvin Young, Andy Anderson, Earl W. Moore, Ben Atkins, and Alton L. "Bud" Chisom. (RFFA.)

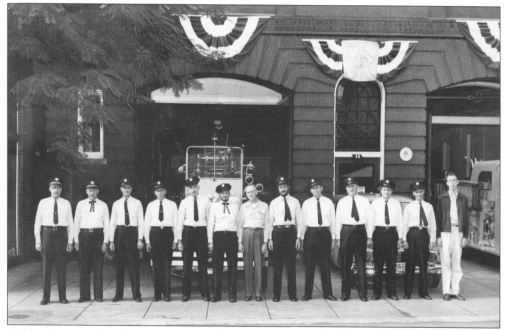

Ladder Company No. 1 poses in front of Station No. 1 in 1957. The men are, from left to right, Johnnie Falls, Sherrill Levi "Gadgett" Lovelace, Leonard Black, Robert Breeden, Aubrey Eugene McGeorge, Walter Cecil "Pierre" Doss, Jerry Jennings, Clinton Mills, Roy Dan Renick, Ed Thompson, Doc Floyd Sweeney, Joseph Allen Trent, and Don Cale. (RFFA.)

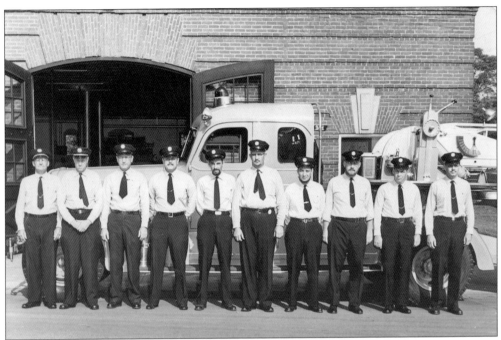

The crew of Ladder No. 2 is, from left to right, Loyd F. Watson, Harry Preston McDaniel Sr., Ralph Lee Stinnett, Lloyd A. Karr, unidentified, Carl "Pinjob" Gibson, Wallace M. "Wally" Maddox, Jackson T. "Tommy" Dews, Burford S. Lugar, and Bill Overstreet in front of Station No. 3 in 1957. (RFFA.)

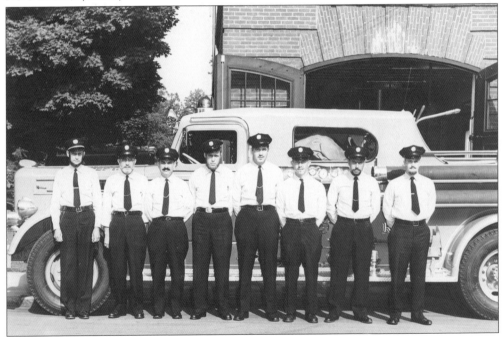

The crew of Engine No. 3 is, from left to right, Garvin Hogan, Elmer Smith, Peter L. "Pete" Price, William C. "Scooter" Scott, Wilson H. "Bill" Kinsey, Raymond E. Cox, Henry Carlton "Frenchy" Laprad, and James Durad Withers Jr. in front of Station No. 3 in 1957. (RFFA.)

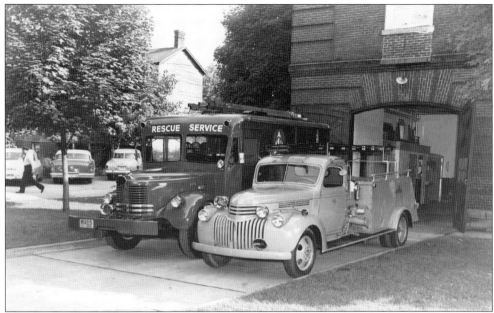

The Rescue Squad was an old World War II Civil Defense truck manufactured by REO. Unit 13 was a 1936 Chevy dump truck that Roanoke City owned. The fire department asked to use the truck after it was taken out of service. Firefighters rebuilt the truck as a fire truck in the bay of Station No. 1. (RFFA.)

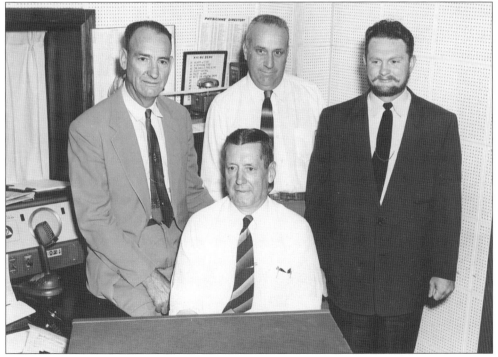

Roanoke fire dispatchers pose for a picture for the Diamond Jubilee inside the dispatch center in 1957. The men from left to right are (standing) Pete Peters, Bill "Sweet Willie" Bolling, and Carl Holt; (sitting) and Harry Daniels. (RFFA.)

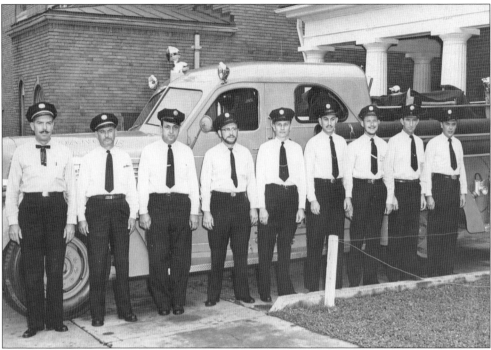

The crew on Engine No. 4, a 1948 Seagrave, consisted of (from left to right) Capt. Sidney Whit Vaughan, Capt. Author J. Hairfield, Morton Hope Poindexter Sr., Lt. James Howard "Pizza Head" Guilliams, Maurice William Wiseman, Robert Norman Guthrie, Harry P. McKinney Jr., George Robert Webb, and James Marvin Dobbins in 1957. (RFFA.)

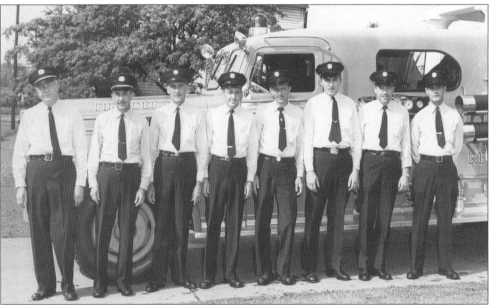

The crew of Engine No. 5, a 1950 Oren, stand outside Station No.5 in 1957. The men from left to right are Capt. Walter "Ann" Dodson, Capt. Howard Lawrence Martin, Lt. John Robert McGuire, Lt. Leonard Nelson Kitts, Walter W. Lambert, Albert J. Crantz Sr., Elmer Basil "Hollywood" Smith, and Bradley C. Robertson. (RFFA.)

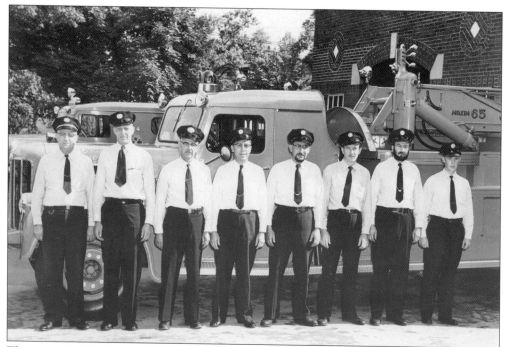

The crew of Ladder No. 2, a 1950 Maxim, stand in front of Station No. 7 in 1957. The men are, from left to right, Capt. Ralph Laughton Smith, Carlton "Slats" Crews, Daniel Flora, Samuel "David" Mitchell, Oliver J. "Abbie" Hall, Paulus W. Moore, Hugh Wade, and Gary Edsel Kelly. (RFFA.)

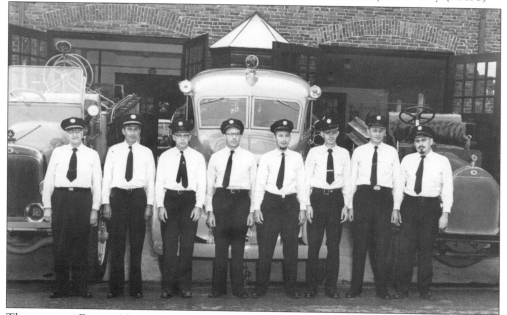

The crew on Engine No. 8, a 1948 Seagrave (center) consisted of Capt. Robert Lee Mutter, Capt. Daniel Ralph Sink, Lt. Blenkey W. Greer, Lt. Everett Ray Walters, William W. Kopcial, Lawrence E. "Bones" Hylton, Warren E. "Floorboard" Hawley, and Donald Barbour in 1957. The other two apparatus, which were reserves, are a 1922 Seagrave (left) and a 1918 Seagrave Brasshead. (RFFA.)

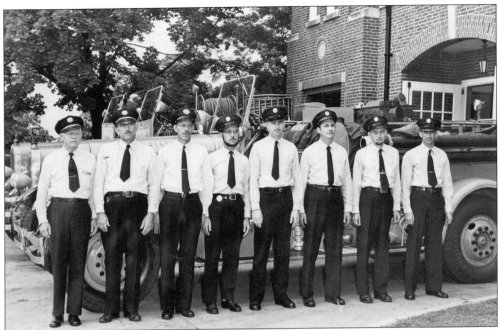

The firefighters of Engine No. 9 stand outside of Station No. 9 in 1957. The firefighters are, from left to right, Edward F. Mullins, George Thomas Belcher, George Victor Cooper, Corbin Wilson, Dwight "Yogi" Yopp, Melvin Earl Wood, James W. Givens, and Gordon "Doe Doe" Barbour. (RFFA.)

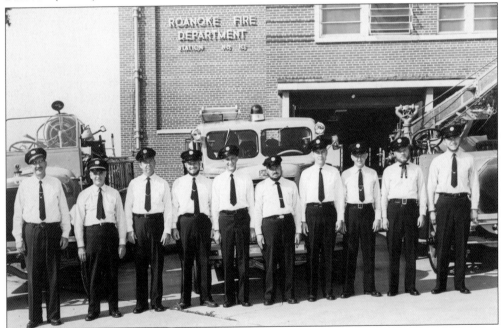

The members of Station No. 2 stand in front of the various apparatus at the station. The men are, from left to right, Jake Burford, Bob Hancock, Wiley Shepherd, Paul Webb, Lester Kelley, Thomas Hubert Radford, John Graham, Wayne Hudson, Bill Bandy, and an unidentified firefighter. (RFFA.)

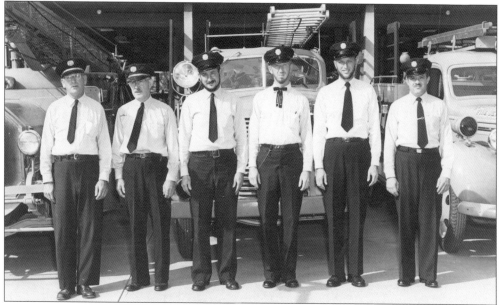

The crew on Engine No. 2 stands in front of their apparatus at station No. 10. The men are, from left to right, Marshall W. "Scortchy" East, William Howard "Hotshot" Boitnott, Alfred "Jack" Willoughby Sr., Edward E. "Eddie" Waldron, Carlton Brooks, and James Henry "Pokey" Turnbull. (RFFA.)

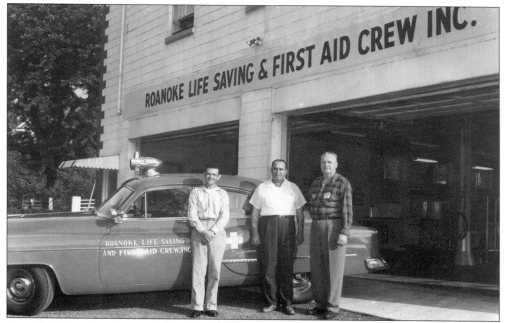

Roanoke Lifesaving Crew members Guy Zimmerman (left), Charles Paxton (center), and Herman Edgar Wills stand outside of their station in 1957. The crew was the first of its kind and was started by Julian Stanley Wise in 1928. Wise went on to become a Roanoke firefighter from September 3, 1932, until April 30, 1945. The Roanoke Lifesaving Crew was absorbed, along with the Williamson Road Lifesaving Crew and the Hunton Lifesaving Crew, into Roanoke Emergency Medical Services (REMS). REMS is still open today in the same building. (RFFA.)

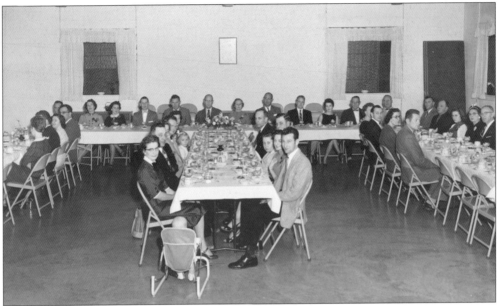

Firefighters enjoy the annual firefighters' banquet at the Masonic Hall on Carroll Avenue in January 1957. Every year, the Roanoke Fire Fighters Association has a Christmas banquet where the firefighters are able to get together with their spouses and celebrate the year. The Firefighter of the Year award and other awards are given out at this banquet. (RFFA.)

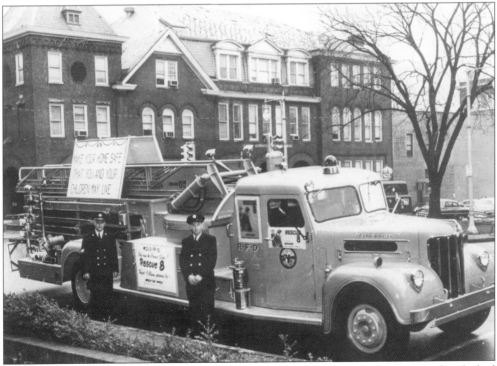

Capt. Howard Martin (left) stands in front of Ladder No. 2, a 65-foot Maxim. The truck is decked out for a fire prevention event featuring *Rescue 8*, a show that WSLS Channel 10 aired, sponsored by the Mick or Mack Grocery Store. (RFFA.)

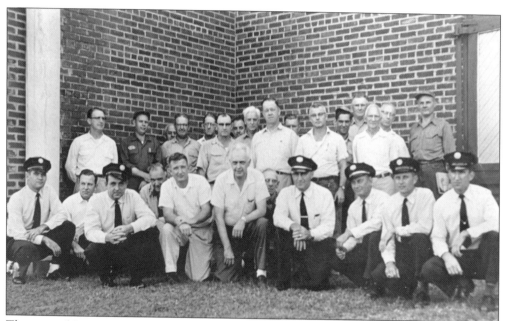

The men of Station No. 4 taught a class to workers for the American Viscose Volunteer Fire Brigade in 1958. This group of men protected the Viscose Plant on Ninth Street SE while they were at work. The firefighters shown in uniform are, from left to right, Rufus E. English, Engineer Morton H. Poindexter Sr., Capt. Alfred K. Hughson, Capt. Author J. Hairfield, Maurice W. Wiseman, and George W. Webb. (RFFA.)

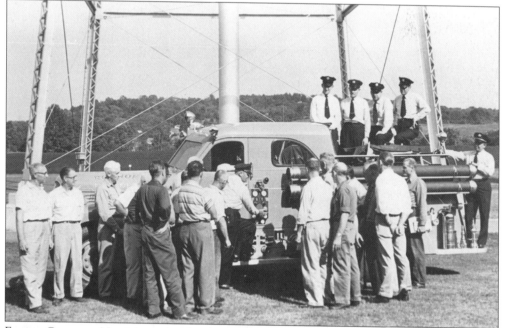

Engine Company No. 4 instructs the American Viscose Volunteer Fire Brigade in 1958 using a 1950 Oren. The drillmaster is Capt. Alfred Hughson, and the firemen are, from left to right, George Webb, Maurice Wiseman, Engineer Morton H. Poindexter Sr., Rufus E. English, and Capt. Author J. Hairfield. (RFFA.)

Robert C. "Bobby" Poole watches as Don Barbour administers first aid to a patient. (RFFA.)

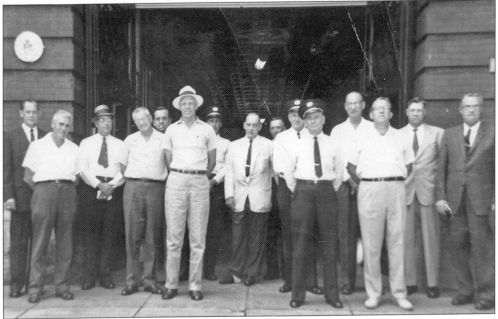

In July 1961, the men who were hired on January 1, 1936, were awarded 25-year pins. These men were hired at the same time when the fire department added the second platoon. Pictured here from left to right are W. Garven Hogan, Robert M. Hancock, Chief John Verlie Brown, Robert Lee Mutter, Morton Hope Poindexter Sr., Carlton B. Crews, Daniel Ralph Sink, Mayor Vincent S. Wheeler, Howard Lawrence Martin, Sherrill Levi Lovelace, Author J. Hairfield, Maynard C. Peters, Reginald J. Morgan, Henry Preston McDaniel Sr., and Johnnie J. Falls. William H. McFarland and Fred L. Johnson were also awarded 25-year pins but are not pictured. (RFFA.)

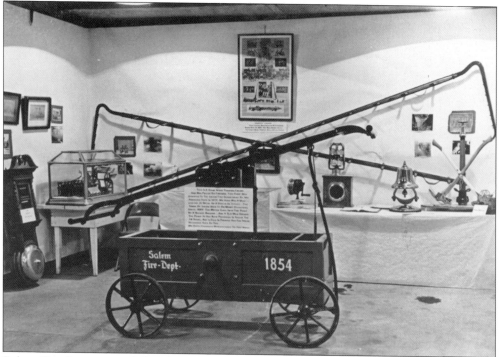

Salem Fire Department's hand-pumper from 1854 is on display at the Harvest Festival in 1967. (RFFA.)

From left to right, Robert Gale Cassell, Jack Heath (police,), Howard Hylton (police), William C. Overstreet, and Rufus Elbert English talk inside Victory Stadium during the Harvest Festival in 1967. (RFFA.)

At the Harvest Festival held in Victory Stadium, the Roanoke Fire Fighters Association Local 1132 set up a fire prevention display in October 1967. The festival was celebrating its 10th anniversary. The display featured the history of the fire department as well as the major causes of fires and their cost to the public. (RFFA.)

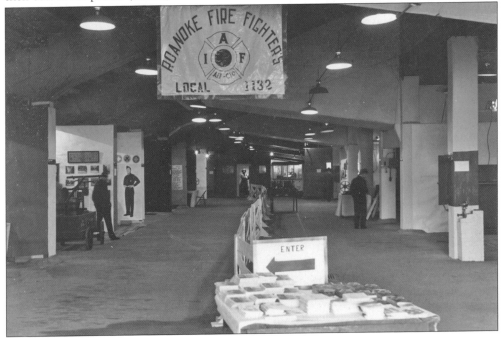

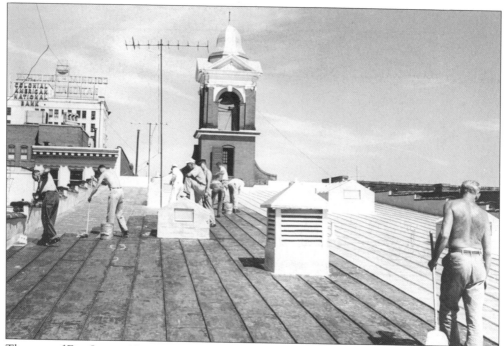

The men of Fire Station No. 1 paint the roof in August 1962. The firefighters kept up the stations' maintenance, built additions, and painted, among other things. Eventually most of these jobs became responsibilities of the various city departments. (RFFA.)

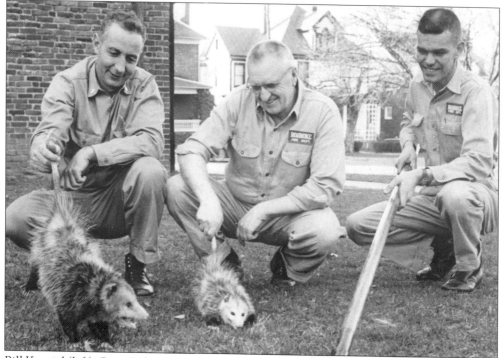

Bill Kopcial (left), Capt. Robert Mutter (center), and Lawrence Hylton hold a couple of opossums by the tail outside of Fire Station No. 8 in Crystal Spring. (RFFA.)

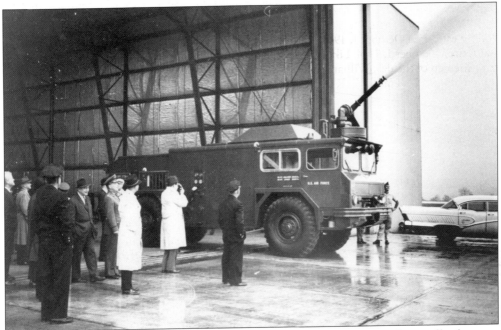

The Airport Crash Crew protected Woodrum Field during emergencies. Originally the crew responded from station No. 10 on Noble Avenue. The first Airport Rescue Fire Fighting (ARFF) truck was a 1948 Jeepster that carried Purple K, a dry chemical used to extinguish flammable liquids. The second trucks were two 1958 Walters (one pictured) that were acquired from the army. (RFFA.)

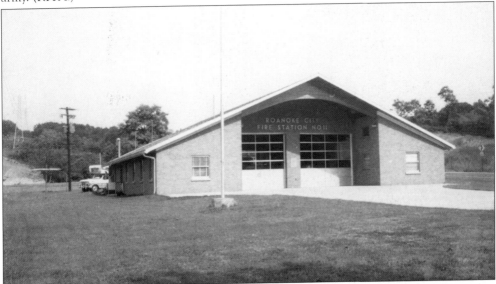

When the Garden City area of Roanoke City was annexed, the fire department became a combined paid and volunteer organization for the first time since the department went fully paid in 1907. The volunteers who protected the Garden City area only remained in service for a couple of years after the annexation until a station could be built. Fire Station No. 11 was opened on March 14, 1964, at 1502 Riverland Road SE, and Engine No. 11 was placed into service with eight men. (RFFA.)

Dispatcher William Revone Bolling operates fire lane controls in 1965. Bolling was hired October 1, 1943, and retired October 1, 1974. Like most firemen of the day, William had a nickname: "Sweet Willie." (RFFA.)

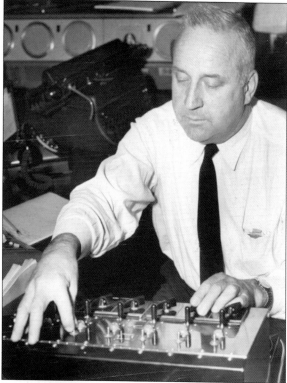

The men work on a fire engine at Fire Station No. 1. Most of the apparatus maintenance and even some apparatus construction occurred at No. 1 for many years. The men are, from left to right, Sidney Vaughan, Aubrey McGeorge, Morton H. Poindexter, and Loyd Watson. (RFFA.)

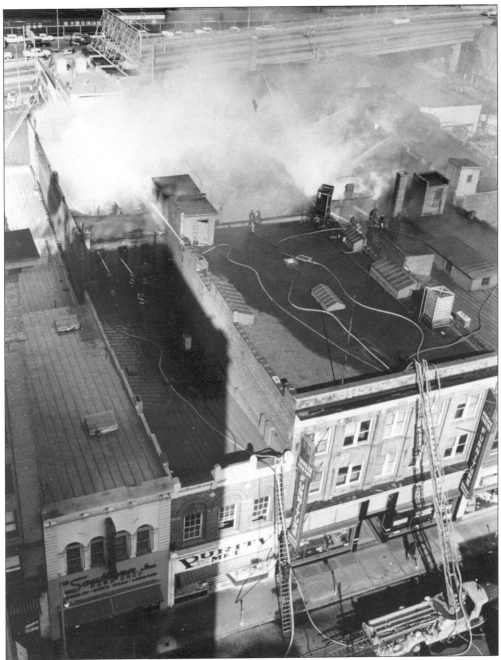

The Morgan-Eubanks Furniture Company caught fire on January 26, 1966, for the second time in four years. Firefighters battled the fire in sub-freezing temperatures for several hours before bringing it under control. During the fire, the hose supplying water up the ladder of one of the ladder trucks burst and had to be replaced. The firefighters lowered the ladder and swapped out the hose, but when they raised it back up, the ropes used to adjust the position of the nozzle weren't working. Finally a firefighter had to climb the ladder to fix the rope and reposition the stream. The building was located in the first block of Campbell Avenue SE. This picture was taken from the Colonial-American Bank Building across the street. (RFFA.)

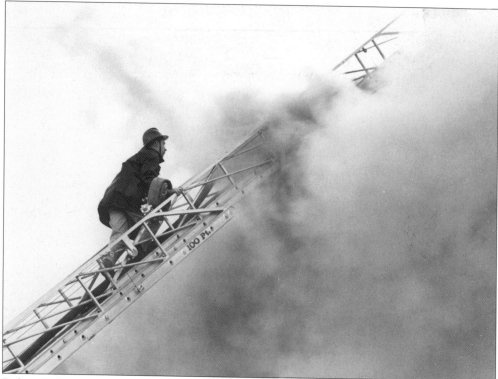

Dalton E. Swanson climbs an aerial ladder to deploy a cellar nozzle at the Morgan-Eubanks Furniture Company fire. (RFFA.)

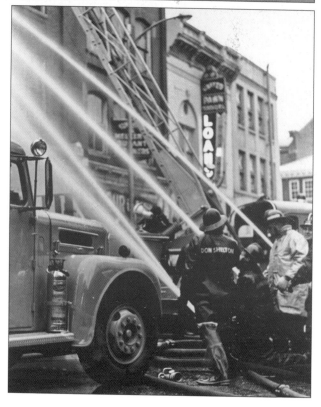

Don Shelton and other firefighters mount a defensive attack on the Morgan Eubanks fire, which they were able to keep from spreading to other structures. (RFFA.)

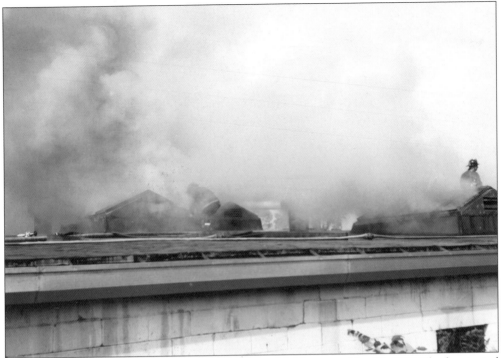

The Huttig Sash and Door building caught fire around 8:00 a.m. on May 26, 1967. The fire started in the paint shop of the plant and spread to the woodworking machinery. Firefighters brought the blaze under control in about three hours. The plant was located at 1809 West Campbell Avenue. (RFFA.)

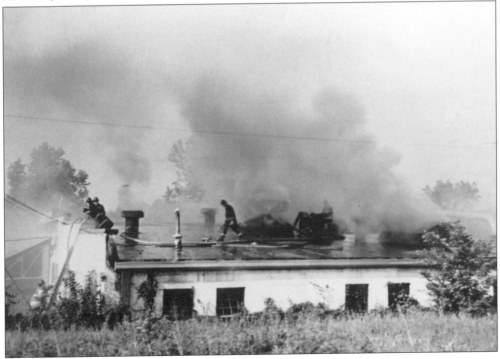

Firefighters bring a woman down from the United States Government building at 211 West Campbell Avenue. The truck is a 1950-model Maxim with a 65-foot aerial ladder. (RFFA.)

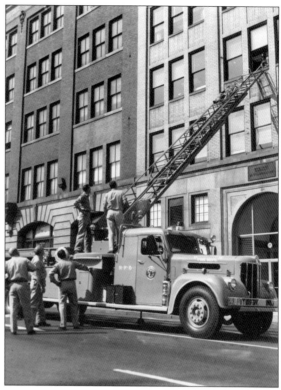

Firefighters attend a memorial service at Greene Memorial Methodist Church for fallen firefighters June 4, 1967. The members of color guard from left to right are Gene D. Kelly, William C. "Bill" Overstreet, unidentified, Johnny Dalton Guthrie, unidentified, and Billy R. Hanes. The firefighters at the front of the altar from left to right are Carl Cletus Holt, W. Garvin Hogan, Chief Sidney Vaughan at the podium, Corbin L. Wilson, and Wilbur A. "Preacher" Drewery. The service was hosted by the Roanoke Fire Department, and the committee for the event consisted of Chairman Carl Holt, Samuel D. Mitchell, Garvin Hogan, Wilbur Drewery, and Corbin Wilson. (Courtesy of Corbin Wilson.)

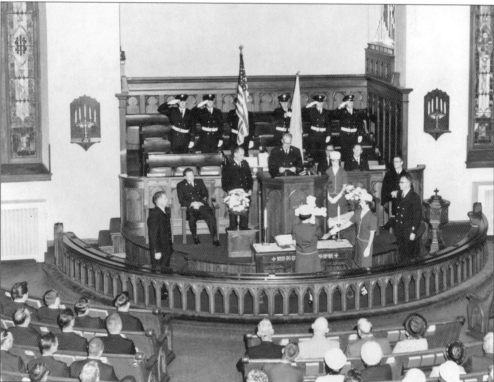

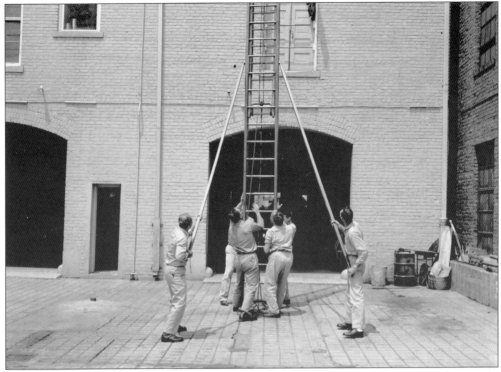

The firefighters train with a 50-foot extension ladder. The ladder has tormentor poles to help raise and stabilize the ladder. Due to the size and weight of the ladder, about six men are needed to raise it. (HMWV.)

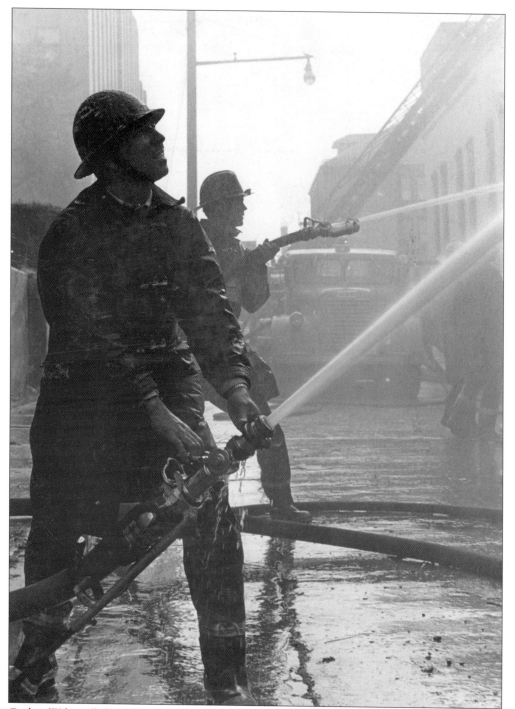

Corbin Wilson (left) and Howard Rader fight a fire at Max King's Parking Garage on September 30, 1968. The fire caused $8,000 damage to the garage and took firefighters about an hour to get under control. The garage, located at 28 Centre Avenue NW, was a total loss. (Courtesy of Corbin Wilson.)

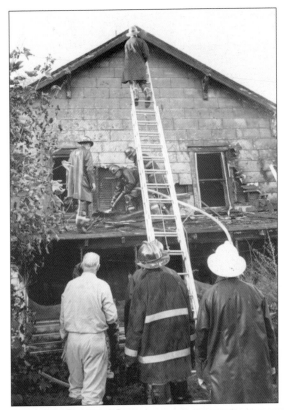

Engine No. 6, Engine No. 11, and Ladder No. 1 responded to this house fire in the 1600 block of Lawrence Avenue SE on October 10, 1969. On the ground, Carlton Crews (left), Leroy Dickerson (center), and A. J. Kingery watch as crews finish up overhaul on the back porch roof. (Wayne Deel; Courtesy of Alvis Kelley.)

Firefighters operate on the roof of a house fire on Walnut Avenue June 30, 1969. (Wayne Deel; Courtesy of Alvis Kelley.)

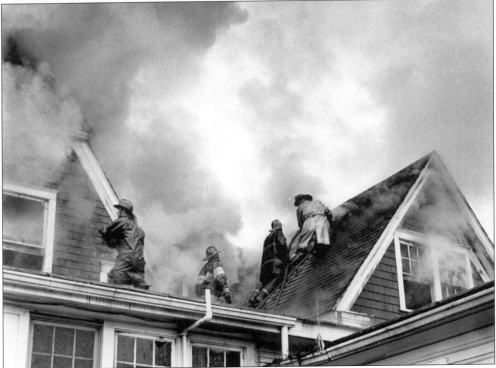

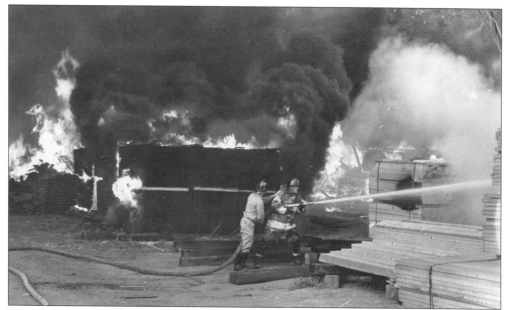

The Home Lumber Corporation caught fire on May 23, 1968. The lumber company was located at Seventeenth Street and Cleveland Avenue SW. The firefighters responded around 7:00 p.m. and had the fire under control in about an hour and a half. Several firefighters sustained minor injuries in which the Roanoke Lifesaving Crew provide first aid. The crew also provided coffee and doughnuts for the firefighters and remained on scene most of the evening. (Wayne Deel; Courtesy of Alvis Kelley.)

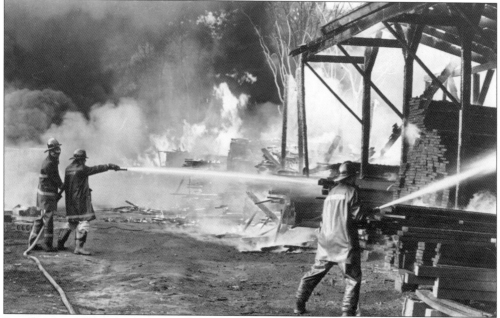

Don Hawley (left) and Don Shelton battle the lumberyard fire, which spread to the Sam Finley Asphalt and Paving Company and the New River Electrical Corporation. It was estimated that 5,000 people crowded the sidewalks to watch the firefighters battle the flames. (Wayne Deel; Courtesy of Alvis Kelley.)

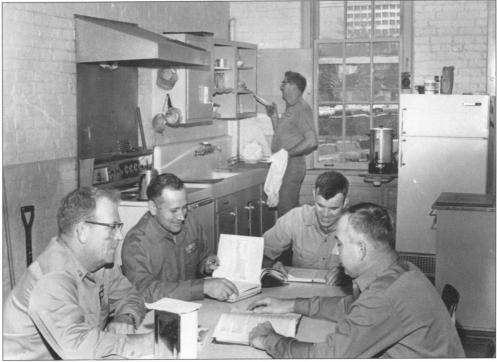

Wilson Kinsey puts the dishes away at Fire Station No. 1 while Tommy Dews, Alvis Kelley, Colonel Holt, and Dwight Yopp (pictured from left to right) sit at the dinner table and train after lunch. (Wayne Deel; Courtesy of Alvis Kelley.)

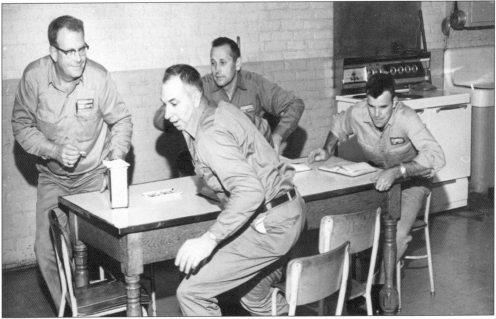

From left to right, Tommy Dews, Dwight Yopp, Alvis Kelley, and Colonel Holt jump when the alarm bell sounds indicating an emergency. The men stop whatever they are doing when that bell sounds. (Wayne Deel; Courtesy of Alvis Kelley.)

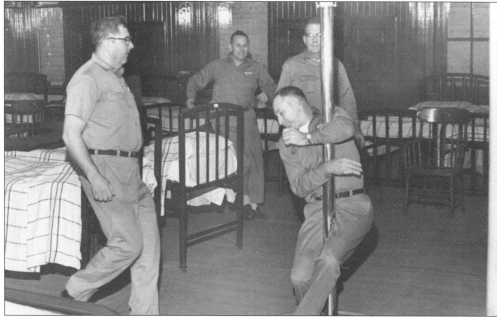

From left to right, Wilson Kinsey, Alvis Kelley, and Tommy Dews get ready to follow behind Dwight Yopp on the pole. Fire Station No. 1 has the tallest pole in the city because of its higher ceilings. Fire poles can still be found in the two-story stations in the city, although most only have one pole remaining; the others have been removed. (Wayne Deel; Courtesy of Alvis Kelley.)

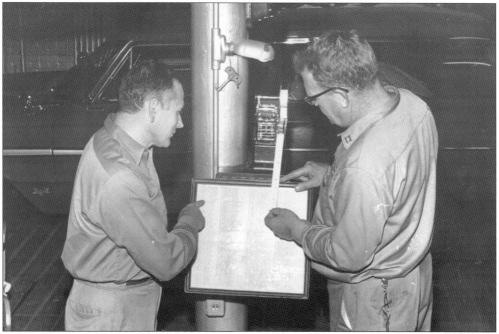

Alvis Kelley (left) and Tommy Dews look over the ticker tape at No. 1 to see which alarm box was received and being dispatched. The ticker punched a series of holes in the tape corresponding to the box number. The firefighters were also notified by bells that rang along with the tape readout. (Wayne Deel; Courtesy of Alvis Kelley.)

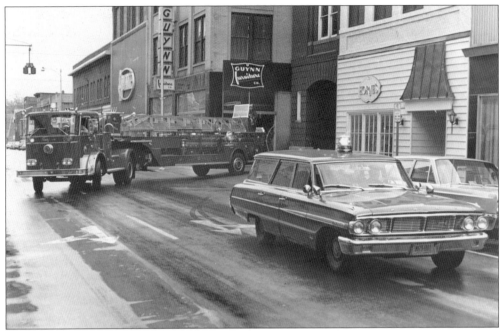

Ladder No. 1, a 1968 100-foot Seagrave, pulls out onto Church Avenue following the chief's car, a 1965 Ford, on the way to an alarm. Alvis Kelley was driving the tractor and Leroy Dickerson was driving the tiller. The captain of Ladder No. 1 was Captain Sherrill Levi Lovelace. (Wayne Deel; Courtesy of Alvis Kelley.)

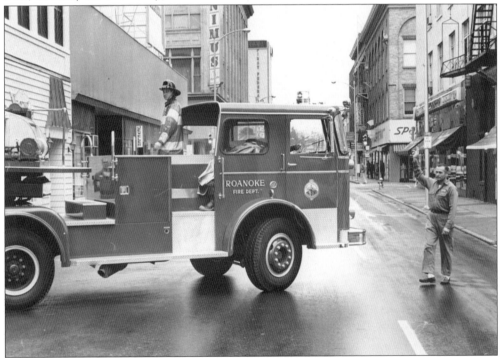

Harold Fitzgerald stands in the jump seat of Ladder No. 1 as Alvis Kelley assists Leroy Dickerson with backing into Station No. 1. (Wayne Deel; Courtesy of Alvis Kelley.)

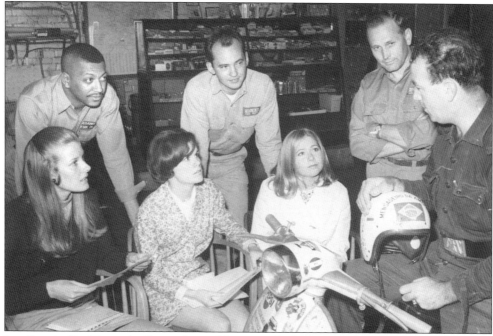

Jose Ferreira Da Silva rode all over the world stopping by fire stations on a goodwill tour. Da Silva was a television actor and an honorary firefighter for a television series he did on firefighting. The women pictured from left to right are Kathy Dews, Nancy Fairbrother, and Coralle Towne. The women translated Jose Ferreira Da Silva's words for the firefighters who are, from left to right, Leroy Dickerson, Harold Fitzgerald, and Alvis Kelley at fire station No. 1. (Wayne Deel, Courtesy of Alvis Kelley.)

The firefighters of Station No. 7 pose in front of Ladder No. 2. The men are, from left to right, (first row) Danny Hughes, Charlie Fields, and Bobby Slayton; (second row) Clayton Sink, Wayne Hudson, Don Hawley, and Gary Moorefield. (Wayne Deel; Courtesy of Alvis Kelley.)

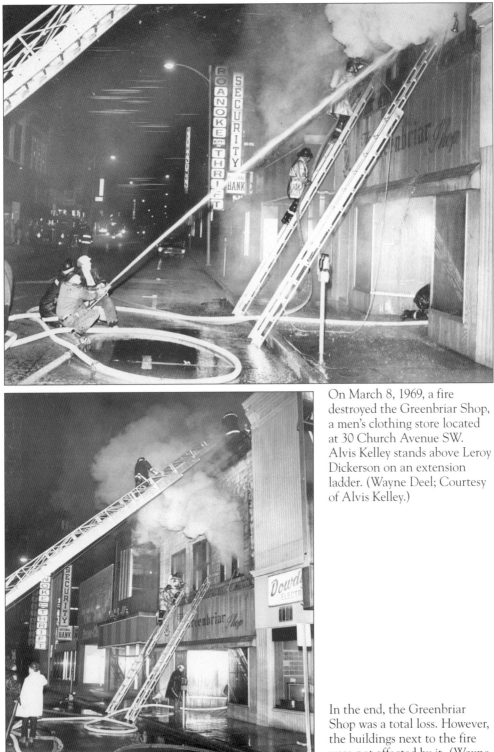

On March 8, 1969, a fire destroyed the Greenbriar Shop, a men's clothing store located at 30 Church Avenue SW. Alvis Kelley stands above Leroy Dickerson on an extension ladder. (Wayne Deel; Courtesy of Alvis Kelley.)

In the end, the Greenbriar Shop was a total loss. However, the buildings next to the fire were not affected by it. (Wayne Deel; Courtesy of Alvis Kelley.)

Firefighters responded at 5:46 p.m. to King's Auto Service in the 500 block of Salem Avenue SW on December 12, 1969. Firefighters arrived shortly after an explosion occurred and blew out the front window of the building. Four cars burned up in the fire, which took the firefighters about an hour to bring under control. Ten minutes after the firefighters cleared up from that fire, an alarm came in for a fire across the street from King's at the Kroger Bakery at 8:06 p.m. The fire at the bakery was confined to a metal storage shed apart from the main building. (Wayne Deel; Courtesy of Alvis Kelley.)

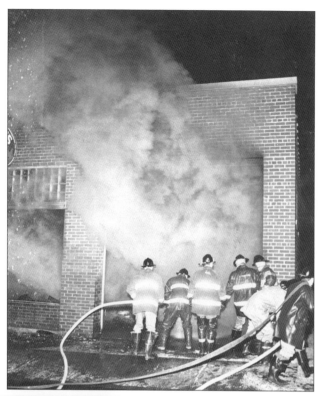

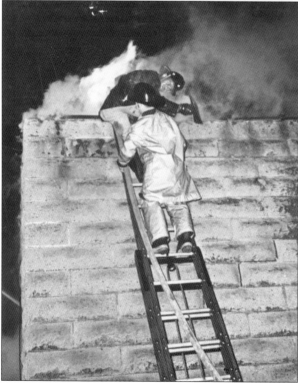

Jimmy Jennings (on ladder) and Nelson Reed fight a fire in the 100 block of Loudon Avenue on August 13, 1969. Engine Companies No. 5 and No. 3 and Ladder No. 1 responded to the call at 10:30 p.m. (Courtesy of Jimmy Jennings.)

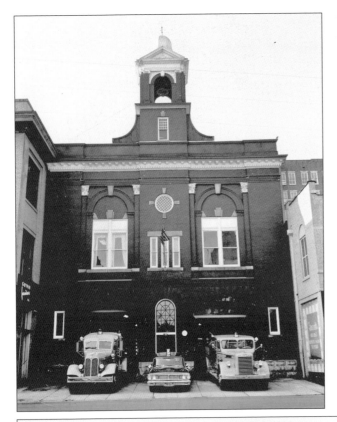

Fire Station No. 1 in the 1960s was equipped with a 1953 Seagrave ladder truck, a 1964 Ford chief's car, and a 1950 Oren engine. Roanoke's Fire Station No. 1 was placed on the Virginia Historic Landmarks Register on September 22, 1972. At the time, the city was planning on replacing the aging structure and possibly making it a museum. The firehouse was built in 1906 and opened in March 1907. Station No. 1 is reminiscent of Independence Hall in Philadelphia. (HMWV.)

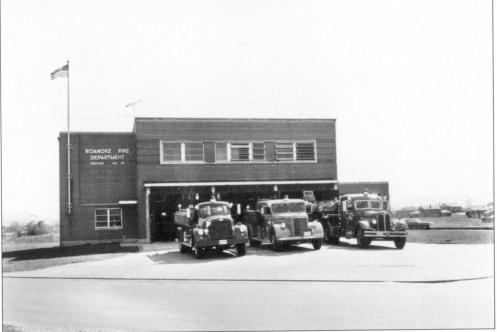

Fire Station No. 10 is the shown here with a 1965 International Oren engine (left), 1950 Oren engine (center), and 1953 Seagrave ladder truck. (HMWV.)

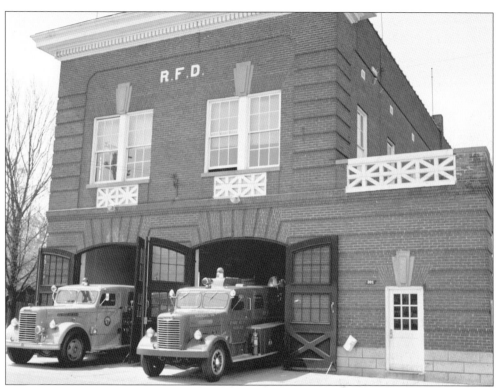

In the 1970s, Fire Station No. 3 is shown with a 1950 Oren engine (left) and an Oren Squad No. 1. Squad No. 1 was a communications truck. (HMWV.)

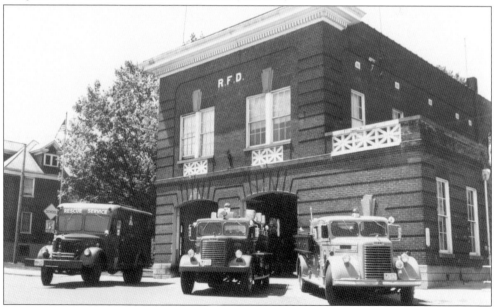

Fire Station No. 3 was equipped with an REO Squad (left), Squad No. 1, and a 1950 Oren in the 1970s. The REO Squad was a Civil Defense truck and was utilized occasionally. The men used to have to make practice runs to Norfolk and intercept an airplane by communication on the way. (HMWV.)

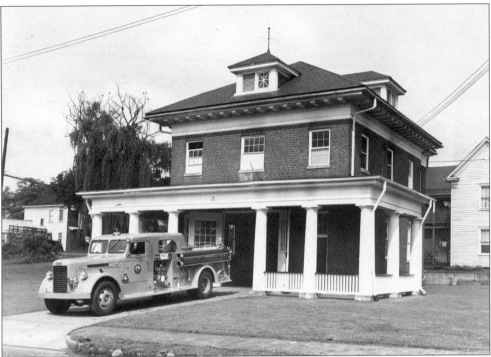

In 1950, the old Engine No. 5 was replaced by a brand-new 1950 Oren. This engine and the others like it were referred to as "Grey Ghost." (RFFA.)

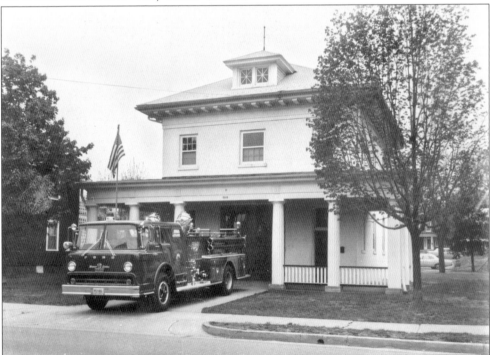

Fire Station No. 6 was equipped with a 1963 Ford engine in the 1970s. Two years later, the department would take delivery of another Ford and place it at Station No. 8. (HMWV.)

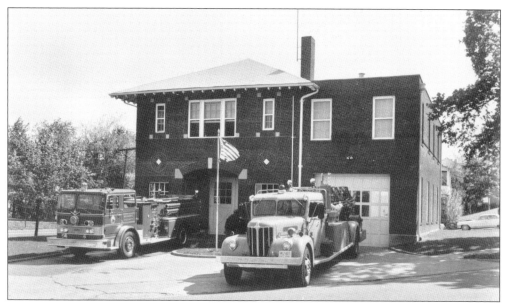

Fire Station No. 7 was equipped with a 1950 Maxim 65-foot ladder truck and a 1969 Oren engine in the 1970s. (HMWV.)

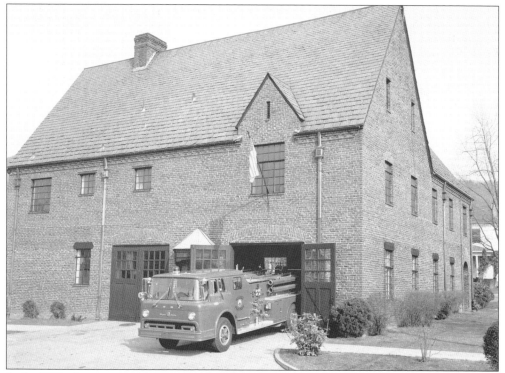

In the 1970s, Station No. 8 was equipped with a 1965 Ford engine. There were two of these engines in Roanoke, built two years apart. These engines were eventually painted yellow after 1979, when Chief Carl Holt changed the fleet color. Once Chief Jerry Kerley was sworn in, he changed the color of the fleet back to red. However, the trucks were not painted entirely red. The new paint scheme was white over red. This color scheme is still used today. (HMWV.)

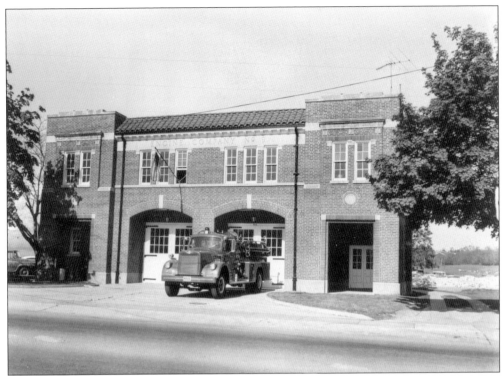

In the 1970s, Station No. 9 was equipped with a 1963 International Oren. (HMWV.)

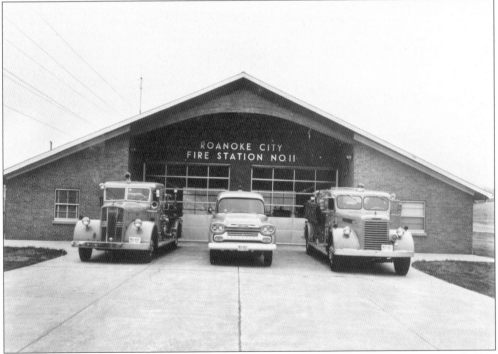

In the 1970s, Station No. 11 was equipped with a 1949 Ward LaFrance engine in reserve (left), a Chevrolet utility truck, and a 1950 Oren, which was the staffed front-line engine. (HMWV.)

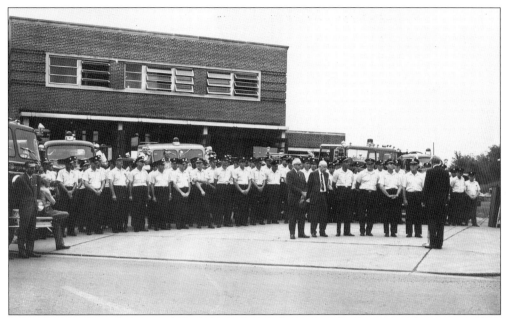

Roanoke firefighters line up with firefighters from Salem, Roanoke County, and Vinton as Chief Sidney Vaughan passes command of the department to Chief Alfred K. Hughson on August 4, 1970. Chief Vaughan retired after 35 years in the department, serving his last eight years as chief. Chief Hughson would go on to serve as chief for three years, retiring with 38 years in the department. The event was held at Fire Station No. 10 on Noble Avenue, now known as Fire Station No. 2. (RFFA.)

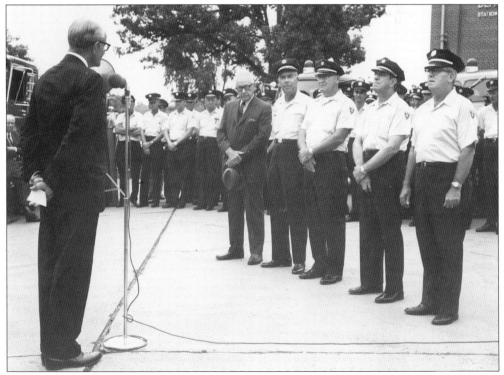

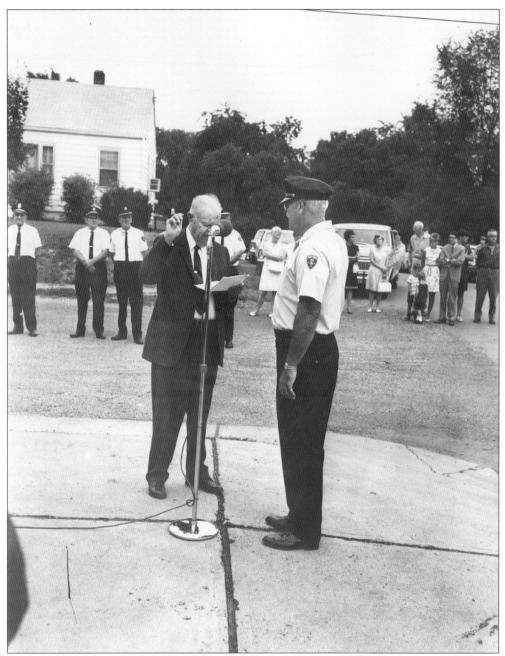

Judge S. L. Fellers swears in Chief Alfred Hughson. Hughson was hired on September 2, 1935. Prior to becoming chief, Alfred Hughson was an integral part of the formation of the International Association of Firefighters Local 1132, the Roanoke Fire Fighters Association. (RFFA.)

Five

THE THIRD PLATOON

In December 1971, Roanoke City Council approved the hiring of additional firefighters in order to create a third platoon. This would decrease the work hours of firefighters from 62.5 hours to 56 hours each week. In March 1972, the fire department began hiring 22 men for the addition. However, the rollout of the new platoon did not go exactly as planned. About a week after phone calls were made to the new recruits, City Manager Julian F. Hirst was told that the city never appropriated the money for the additional salaries when it approved the firefighters. Many men who had already received the call to show up to work at the fire station received another call telling them not to. Unfortunately, these men had already quit their jobs. On top of that, Hirst asked that Chief Hughson suspend the hiring in order to recruit more black firefighters. At the time, Roanoke only had a few black firefighters. Days later, on March 7, 1972, the 12 recruits who had been called were put on the job. After the filing period for the black recruits, the city was left with 10 applications, nine new ones and one that was already on the list. Three black applicants remained after the testing and processing of the applications. One of these applicants removed himself from the hiring. In the end, the two remaining black men and eight white men were hired, filling the total 22 positions needed to create the third platoon. In the interim, the on-duty firefighters gave up all vacation in order to put the third platoon into place on time. During the restructuring of the department, 48 firefighters were promoted. Before the third platoon, each station had five men per apparatus, and the men worked every other day with three Kelly days each month. After the restructuring, the stations had four men per apparatus, and the men had a cycle of working every other day until they had worked three days. The men were then given a four-day break before starting another cycle. This schedule is still in place today.

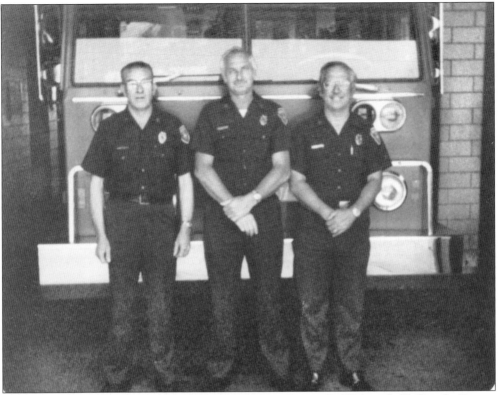

Everett R. Walters (left), Dwight Yopp (center), and Corbin Wilson stand in front of Engine No. 2 at Fire Station No. 10 in 1972. (RFFA.)

The Roanoke Fire Department has been fortunate to have several family members employed over the years. Once one person was hired, their brother or son might learn of the job and become interested. The Poindexters saw three generations of firefighters join two departments in the Roanoke Valley. The men pictured are, from left to right, (first row) James D. Poindexter, hired August 1, 1972, and Morton H. Poindexter Sr., hired July 1, 1936; (second row) Morton H. Poindexter Jr., hired October 1, 1961, and Brady "Bill" William Poindexter, hired April 7, 1973. Morton Sr. was the father of Morton Jr., Brady, and James. James's son Jimmy became a firefighter for the neighboring Salem Fire Department. (RFFA.)

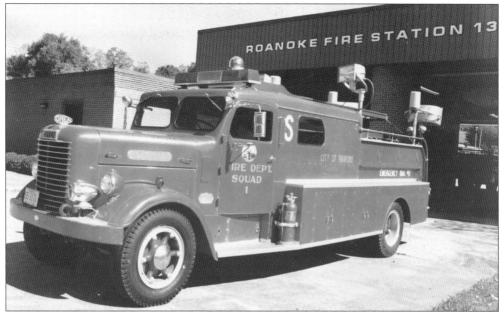

Fire Station No. 13 was originally opened in 1967; the station was located behind the current station at 4330 Appleton Avenue NW. The current station (pictured) was opened in 1978. Station No. 13 was created after the annexation of the Hershberger Road and Woodrum Field areas. Here the old Squad 1, a communication truck, sits shortly before being taken out of service. Currently this truck is completely restored and is owned by a private collector. (RFFA.)

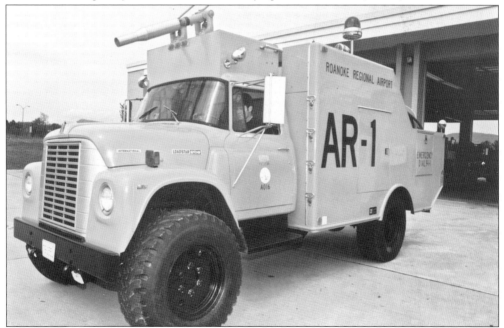

Fire Station No. 10 was opened on March 14, 1974, to service the airport and Crossroads area of northwest Roanoke. The Airport Crash Crew was moved into the station after several years of apparatus being housed in a hanger. The old AR-1, shown with Ernie Brown driving, carried 500 pounds of dry powder and was taken out of service after many years of operation. (RFFA.)

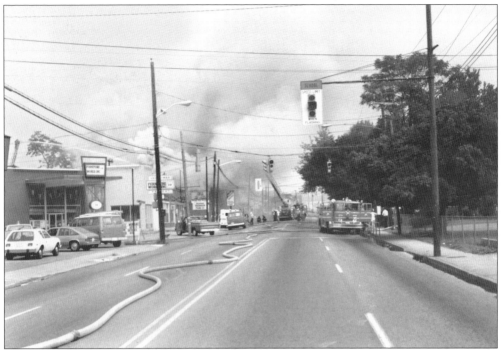

The Richard Ridenhour Piano Company caught fire in the late 1970s. The business was located in the 1000 block of Williamson Road. The firefighters had a difficult time reaching the fire, which consumed the attic of the structure.

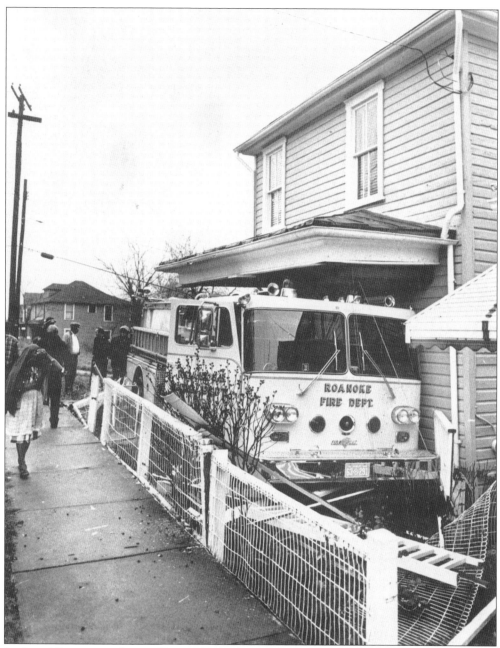

Lt. James Patton was driving Engine No. 3 for Captain Robert Guthrie and firefighter David Trent when the steering linkage broke in 1980. The engine came to rest against this house in northwest Roanoke. Luckily no one was injured in the accident. (RFFA.)

The crews of Engine No. 7 and Ladder No. 2 stand outside of Station No. 7 in 1984 to celebrate John Ballentine's retirement. The men are, from left to right, Wayne Perkins, Bev Mitchell, Frank Adams, Butch Ferguson, John Ballentine, Gary Clark, Buddy Helms, Bob Muse, and Bobby Ross. (Courtesy of Beverly Mitchell.)

This is the recruit school from 1984. At this time, the men were hired and put on the job, and when there were enough recruits, they would go through recruit school. Currently a group of firefighters are hired at the same time, attend a 15-week recruit school, then graduate and are placed in the company. The men are, from left to right, (first row) Michael W. Milton, John H. Dubose, Curtis B. Gibson, and Daniel P. Hughes, (second row) Ronald L. Williams, Thomas J. Ransome, Jeffrey D. Dudley, John D. Proctor, Edward E. Fielder, Roger L. Markham, Cecil D. Boyd, Kenneth L. Furrow, Jeff W. Beckner, and instructor Nelson Reed. (RFFA.)

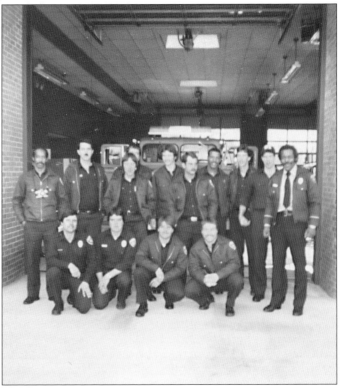

The men of Engine No. 6 in 1983 from left to right were Michael Banks, James Poindexter, Lawrence Breeding, and Maurice Wiseman. (RFFA.)

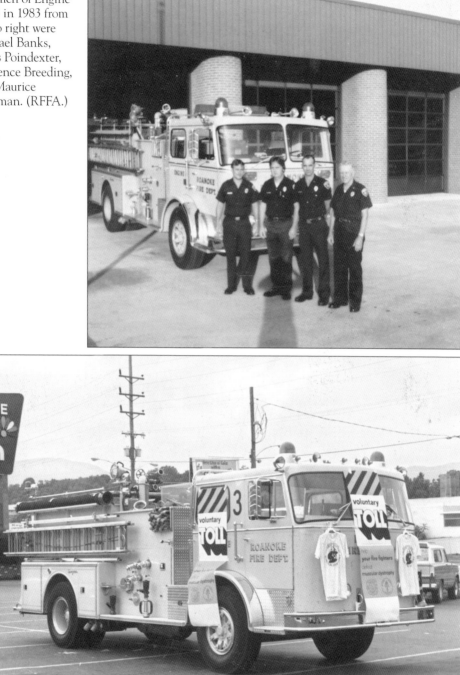

Engine No. 3 sits at the Roanoke Salem Plaza decorated with banners for the Muscular Dystrophy Association. The Roanoke Fire Fighters Association, along with the International Association of Firefighters (IAFF), has made the Muscular Dystrophy Association their cause and raises money for them each year. The IAFF has raised money through "Fill the Boot" campaigns all across the country since 1954. (RFFA.)

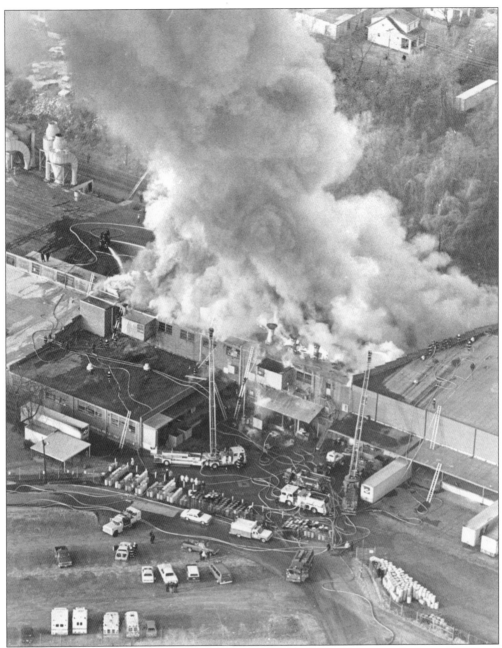

On February 18, 1985, the Singer Furniture Company's finishing building caught fire at 3322 Read Road NE. Three people were killed in the fire, which received national news coverage. (RFFA.)

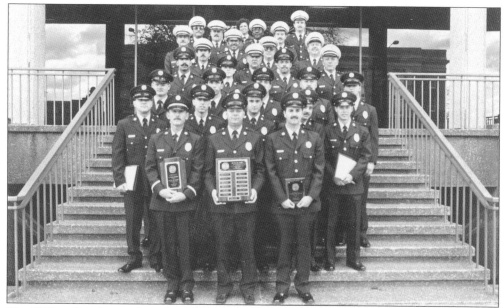

The 1989 rookie class and senior staff of the Roanoke Fire Department stand on the steps of the Municipal Building. The men and women are, from left to right, (first row) Charlie Fochtman (instructor), Barry Simmons, and Mark Kesterson (instructor); (second row) Ronnie Cochran, Clayton Fowler, William Humbert, Allen Austin, and Richard "Skippy" Flora; (third row) Michael Armstrong, Phil Chitwood, Lynn Flora, Kenny Campbell, and Farren Webb; (fourth row) Jon Willdigg, Mike Rose, John Arrington, and Winston Simmons; (fifth row) Pat Taylor and James Patton; (sixth row) Peter Kandis, Johnny Johnson, and Billy Southall; (seventh row) Rawleigh Quarles, David Deck, Carol Wells, John Anderson, Jerry Purcell, and Eddie Fielder. (RFFA.)

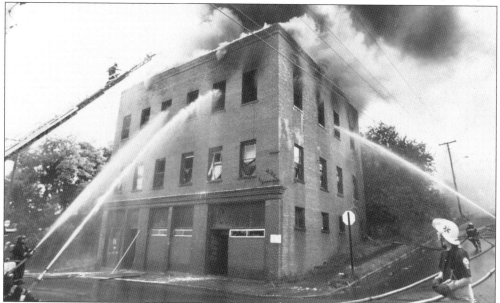

On June 8, 1991, the YMCA caught fire at the corner of Patton Avenue and Gainsboro Road NW. The firefighters battled the fire from the exterior because the fire rendered the building too unstable for interior operations. (RFFA.)

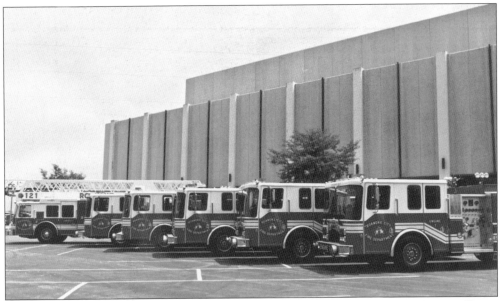

The Roanoke Fire Department took delivery of five Grumman engines in 1991 as well as a Grumman 121-foot ladder truck. The new apparatus was a welcome sight for the firefighters, who had been working on old, outdated apparatus. The vehicles were lined up at the Roanoke Civic Center to be shown off for everyone to see. (RFFA.)

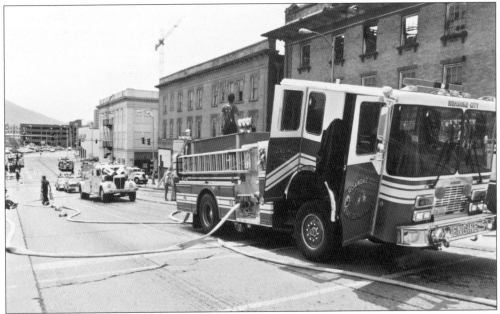

After sitting vacant for years, the Hotel Earle was destroyed by fire on August 23, 1991. Four ladder trucks, nine engines, and their crews battled the fire, which was reported at 7:49 a.m. By 11:00 a.m., smoke and steam were still billowing from the building, though the fire was under control. The new Grumman engines were put to the test for the first time at this fire. Much like the older engines, the cabs on the new engines had to be lifted because they were overheating. Later Grumman would realize that vents would be required on the sides of the cabs to let the engines cool properly. (RFFA.)

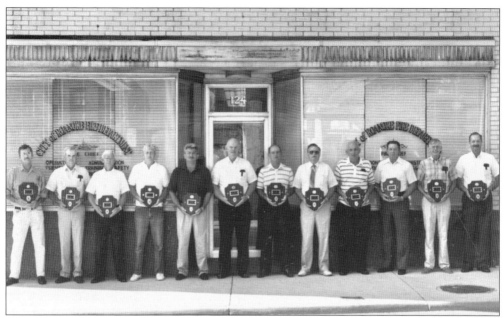

In 1991, Roanoke City offered a "buy out" of the firefighters who were able to retire. If the firefighters agreed to the conditions, they would get supplemental pay until they received Social Security. In effect, the city was saving money by replacing the veteran firefighters who made top pay with brand-new rookies. From left to right, Don Tinsley, Colonel Holt, John Hall, Charlie Brown, Gerald Simmons, Phil Fracker, Brad Robertson, Bill Bandy, Dalton Swanson, Bud Chisom, Don Hawley, and Thomas Burton stand in front of the old fire department headquarters on Luck Avenue with their retirement plaques. (RFFA.)

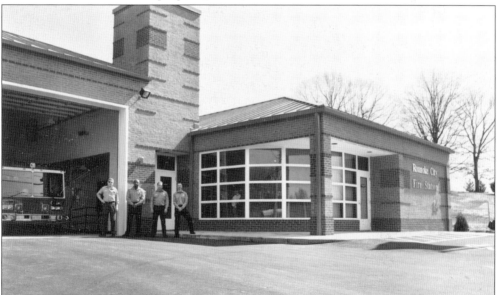

Fire Station No. 14 was opened on March 2, 1992, at 1061 Mecca Street NE. Engine No. 1 was taken out of service, and the men were transferred to the new station where Engine No. 14 was put into service. From left to right, Capt. Melvin Greaser, Lt. Billy Word, Ronald Mathews, and Charles "Chuck" Mills stand out front of the new station. (RFFA.)

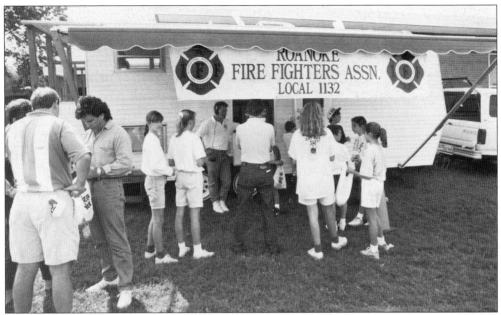

Scott Mutter gives a group of children a tour of the Fire Safety House. The Fire Safety House is a scaled model of an actual house that teaches children what to do in case of a fire. The Roanoke Fire Fighters Association has operated the fire prevention exhibit for many years as an outreach program for children. (RFFA.)

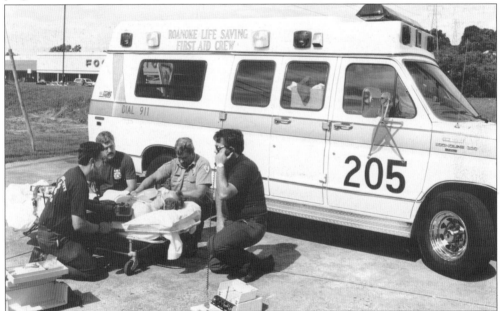

Roanoke City EMS members train with Roanoke Fire Department members so that the firefighters can become first responders. The firefighters were given the opportunity to get a $100 a month stipend if they got their Emergency Medical Technician certification and maintained it. This enabled the fire department to become first responders. The men from left to right are Paramedic Mark Nelson, Firefighter Kenny Campbell, Capt. Carl Epperly, and Paramedic Tim Harris. Clayton Fowler, the third firefighter on Engine No. 11, was the patient. (RFFA.)

From left to right, Chris Trussler, Darren Parker, Ed Crawford, Betty Branch, Rob Humphries, Michael Hanks, and Chuck Wells stand next to the Roanoke Fallen Firefighter Memorial. Branch is the artist who created the statue. It stands as a memorial for the brave men who have lost their lives in Roanoke City in the line of duty. The fallen firefighters include Jacob D. Talley—July 12, 1913; Raymond E. Maxey—February 14, 1954; Frank L. Ferguson—September 2, 1955; Carl A. Cox—October 7, 1972; Robert Gale Cassell—November 1, 1985; and Harvey H. Helm—November 1, 1985. (RFFA.)

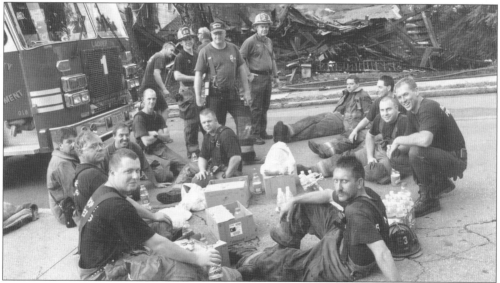

The Roanoke firefighters take a break after an early morning fire in the 800 block of Marshall Avenue. The fire, which destroyed the house in the background, extended to the house next door before firefighters were able to control it. The firefighters standing in front of Ladder No. 1 are, from left to right, Barry Kincer, Rhett Fleitz, Carl Jones, John R. Patterson, and Audie Ferris. The men seated are, clockwise from top right, Tracy Blevins, Tom Mougin, Jamie Brads, Greg Fulton, Willie Wines Jr., Mike Pruitt, Gary Connor, Bill West, Danny "Moose" Hughes, Chad Riddleberger, and Scott Mutter. (Courtesy of Willie Wines Jr.)

ACROSS AMERICA, PEOPLE ARE DISCOVERING SOMETHING WONDERFUL. THEIR HERITAGE.

Arcadia Publishing is the leading local history publisher in the United States. With more than 3,000 titles in print and hundreds of new titles released every year, Arcadia has extensive specialized experience chronicling the history of communities and celebrating America's hidden stories, bringing to life the people, places, and events from the past. To discover the history of other communities across the nation, please visit:

www.arcadiapublishing.com

Customized search tools allow you to find regional history books about the town where you grew up, the cities where your friends and family live, the town where your parents met, or even that retirement spot you've been dreaming about.